PASSING THROUGH

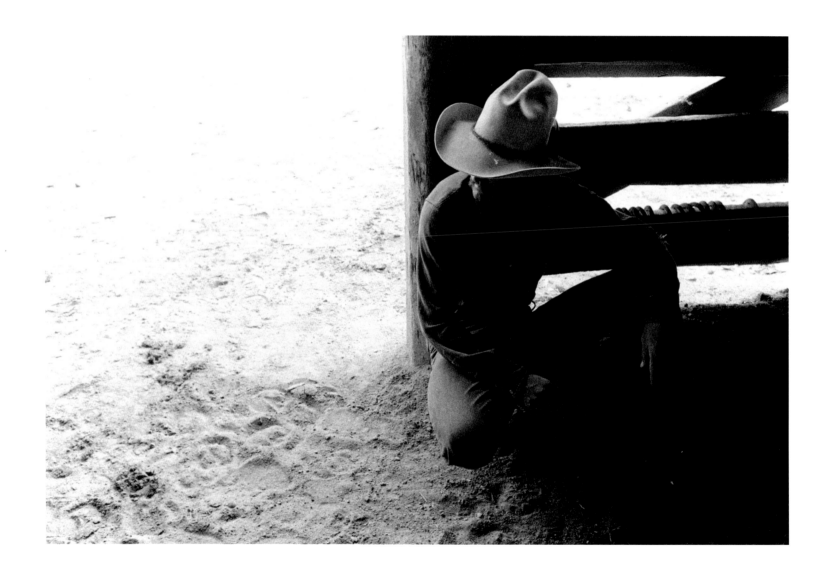

PASSING THROUGH

Western Meditations of Douglas Kent Hall

Photographs by Douglas Kent Hall
Introduction by Alfred Bush

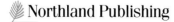 Northland Publishing

To Dawn and Devon—the inspiration

CONTENTS

One | INTRODUCTION *1*

Two | PASSING *7*

Three | COLLABORATION *17*

Four | REVELATION *25*

Five | SUSPENDED *39*

Six | CONFRONTATION *51*

Seven | ENIGMA *69*

Eight | MEDITATIONS *81*

Nine | SILENCE *91*

MYSTERIES *103*

THE PHOTOGRAPHS *113*

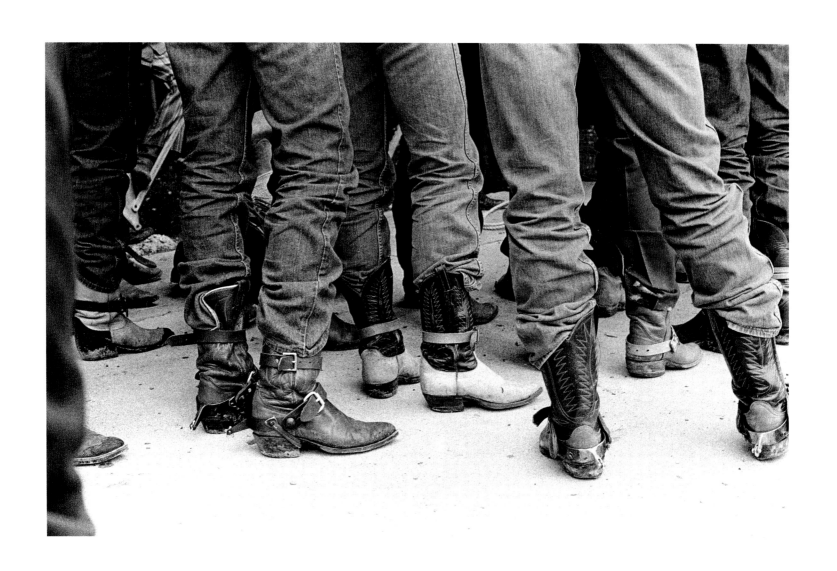

I N T R O D U C T I O N

Passing through.

The desire to move, to change, is a quint-essential Western emotion, and one that lies at the heart of the photography of Douglas Kent Hall. Whether one's parents moved West with the gold seekers of 1849, or the dust flee-ers of 1933, the overland narrative is fresh in family memories. Even the most earth-anchored of Americans—the Pueblo Indians of New Mexico and Arizona, where families continue to live in houses built by their twelfth century ancestors—put migration at the core of their ceremonies. In a landscape whose geological antiquity shrivels any human concepts of age, one cannot escape being reminded of passing through dimensions other than space.

Unshakable photographic reputations, in both centuries, are rooted in years of work in the American West. To photograph America without at least passing through these special regions has become more unthinkable in the twentieth century than in the century of the art's invention. Indeed, most of the great names in American photography have passed through this territory, laden with camera and an obligation to quickly learn to calculate the results of the special light west of the 100th meridian. Even those photographers whose careers are centered elsewhere find it impossible to resist tilting their cameras, at some point, toward the vast spaces, the desert light, the eddies of earth-bound populations that so specially define the West.

But it is not the photographer who passes through in Douglas Kent Hall's vision. Travellers in space (I think of the silhouette in these pages of the car floating through shadows before a quavering, low-lighted desert landscape) and time (the shadow of the man in the parking lot ominously extends to seven times his height) circle the photographer's camera like constellations.

Douglas Kent Hall's West appropriately opens to us at full speed on a desert highway: modern overlanders only slightly more prepared for an overtaking camera than their counterparts a century ago were for the surprise raid on a careening coach.

Unlike the majority of the photographic explorers, who are continually clicking away at the American West, Douglas Hall's camera is firmly rooted in the region's very center. He was born half a century ago on the dinosaur-laden stratigraphics of eastern Utah bordering the Ute reservation. He grew up with cowboys and Indians; even though his education, continuing into graduate school at the Iowa Writers Work-shop, persistently polished him, the cowboy remained.

It is understandable, then, that the most stereotyped of the West's inhabitants—the cowboys, the Indians, the Spanish—should emerge in Hall's photographs as so newly seen. Years of first-hand knowledge firmly push the individuals forward. The cowboy emerges with a gentleness,

2

the Matachines with a ferocious splendor, the Indians with a specificity that engages us anew. Hall's Western icons—the indelible view of the cowboy boots at Mesquite, Texas; the aged Pueblo priest at Picuris; the masked Matachines with death-head palma—stay in our memories with the persistence of the geological formations of his birthplace.

Exactly a century and a half ago, the second invention of photography made possible the duplication of a photographic image, and thus the almost infinite dissemination of visual information. William Henry Fox Talbot's paper negative process, which so closely followed Daguerre's daguerreotypes, is the authentic ancestor of the photographs that surround us so pervasively today. The possibility of duplicating a photographic image was vital to the fulfillment of the complex destiny of the nineteenth century's industrial revolution and its geographic dispersals, and was thus crucially important to the opening of the American West.

Both the daguerreotype and the clumsier but infinitely more functional paraphernalia for producing negatives from which images could be multiplied quickly found their way to America. Fixing the photographic image was one of those inventions that intersected with a receptive era so appropriately that cause and effect cannot be differentiated.

As the trails to the American West became familiar enough to be easily followed, self-taught Daguerrean artists of the 1840s sought subjects along them; their work took them ever-more distant from the Eastern cities, where interest in these astonishing portraits was so keen. By the time those same trails were the well-rutted high-

ways of the 1850s, photographers and their bulky equipment were making negatives of the landscapes, the new townscapes and the inhabitants of both, which would, in turn attract even greater numbers of people eager for the new opportunities of the West, but sufficiently skeptical to wait for incontrovertible evidence to set them on their way.

Ironically, the mid-nineteenth century photographer preserved the wonders of the American West so effectively that he hastened the destruction of its pristine landscapes and traditionally focused native populations. Each photograph testified to the timeliness of the invention in the face of the ever-widening streams of overland migration. The overlanders not only sought what the photograph told them was there, but changed what they found so profoundly that the photographic evidence took on even greater importance. This self-propelling wheel of Western images—the original wonders and the poignancy of their effacement—continues to fascinate the photographer of the West to this day.

Hall's writing, important to him in a way different from his photography, preceded his work with the camera: thus the preponderance of Western writers among his portraits, and the keen narrative sense of many of his photographic series. The photographs are independent works of art, but there is always a text or a context that happily ties them together. Several of the groupings here are selections from longer narratives. The cowboys and rodeo photographs are expanded in Hall's *Let 'Er Buck* (New York, Saturday Review/Dutton, 1973), *Rodeo* (New York, Ballantine, 1975), and *Working Cowboys* (New York, Holt Rinehart and Winston, 1984). The

3

4

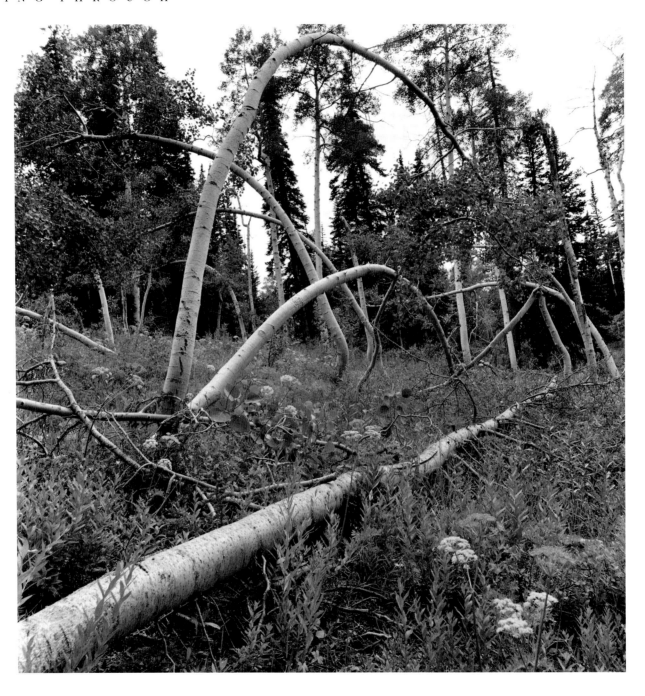

border photographs are found in a much larger context in *The Border* (New York, Abbeville, 1988). The prison series is from *In Prison* (New York, Henry Holt, 1989). The musician's portraits were taken for his *Rock: A World As Bold As Love* (New York, Cowles, 1970).

The photographic subjects have also transformed themselves into narratives in the form of two novels: *On The Way to the Sky* (New York, Saturday Review/Dutton, 1972) and *Rock and Roll Retreat Blues* (New York, Avon, 1974). Purely photographic narratives have appeared as defined series: "Passing" (begun 1968); "Dark Landscapes" (begun 1973); "Hack" (begun 1975); "Van People" (begun 1976); "Lisa in Graphite" (begun 1979); "Green Aspen Meditations" (begun 1987); "Summer Arroyo Meditations" and "The Road to Mecca Meditations" (begun 1988).

Like most photographers, Hall has found travel important. Touring in Europe and Mexico, and longer residences in London and New York City, established him as a photographer whose work is part of important collections, both public and private. But travel also confirmed his place as a Westerner. A dozen years ago, avoiding a West in which television and national chains push all toward sameness, Hall settled with his family into a frontier as different, as difficult and as proudly resistant as even the nineteenth century seldom offered: a village whose Spanish roots reach back to the sixteenth century on New Mexico's Rio Grande. The Matachine photographs, as exotic as Morocco, and probably historically linked, attest not only to the village's vigorous cultural survival, but to Hall's own skills as an observer, and even more impressively, an observer with a camera.

The geography of Hall's West is consistent with a vision rooted in the center. Its two borders, California (so West that it is East in several senses) and the Mexican frontier (another country, neither Mexican nor Yankee), join, like cupped hands, to hold his real West, which gravitates decidedly Southwest. At its core are America's cowboys and Indians, of course; the irony of prison in a territory of relentlessly open space; the exaggerated individualism, the astonishing cultural cohesion of the Matachines. Individuals face the camera: the crafters of the Western narrative, be it fiction, poetry, or song and the ever-moving overlanders, passing through.

ALFRED L. BUSH, *Curator*
Princeton Collections of Western Americana

5

One | # P A S S I N G

To me, photography is a mirror as magical and varied in its ability to move and provoke as the infinite moods and turns of light. When I see a great photographic print or slide, I am instantly drawn into the life that lies beneath its surface. Some flickering likeness I detect there awakens in me a response, and I find myself pursuing it in the same way I pursue all that is illusive and changeable in myself.

One principle shapes my life and governs the flow of my work as an artist. I call it Passing. Passing is everything; Passing is nothing. It is singular and complex, obvious and illusive, trivial and profound. It is the image that dances briefly on the retina and then vanishes before my reflexes fully capture it. But its appearance, as either image or idea, is enough to keep me searching.

Passing is basic, and it is divine. It penetrates all barriers. It brings together both the spectator and the parade, and lineup and the line, the individual and the group. It is that single microinstant between the future and the past. It is all that we are—all that I am.

I was told at an early age that time passes, warned that I could waste time, the implication being that this was sinful. Both notions were wrong, of course. The camera taught me how false these ideas about time were. In a split-second blink, the shutter showed me that time does not pass, nor is it an expendable commodity. It is we who pass, we who are expendable. We pass through time and we waste only ourselves. Time is indifferent to our folly. Time is the one certainty we have, the fixed and constant factor—more concrete, more permanent than space.

Passing came into perspective one summer in the late 1960s when I was driving from Second Mesa in Arizona's Hopi Reservation back to New York City where I was then living. While my friend drove, I photographed the occupants of the cars we passed. The idea attracted me in the way I am always drawn into my best series of photographs. What I saw later in the contact sheets were travelers in space, creatures lost to time. I felt as though I were an alien being who'd been allowed a few brief but telling glimpses into the life of people whose names I did not and never would know. They were space people, trapped in their machines, caught there, suspended—passing.

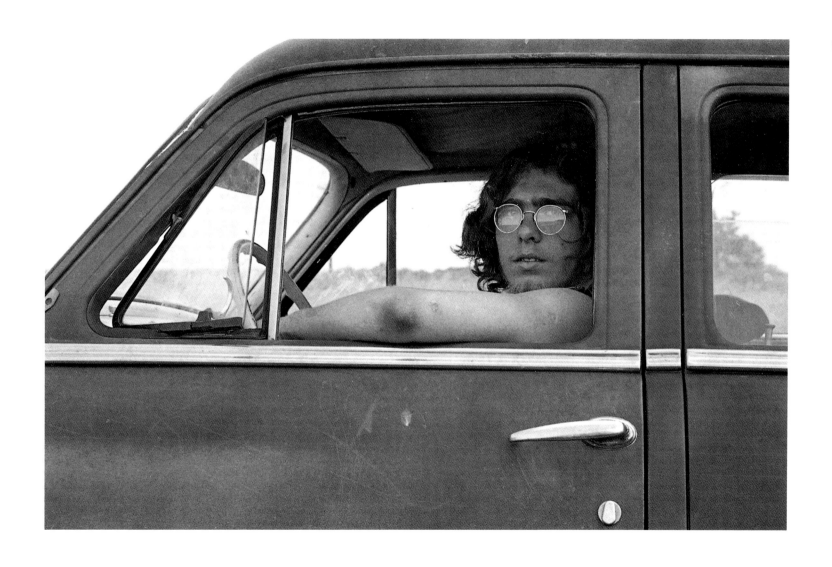

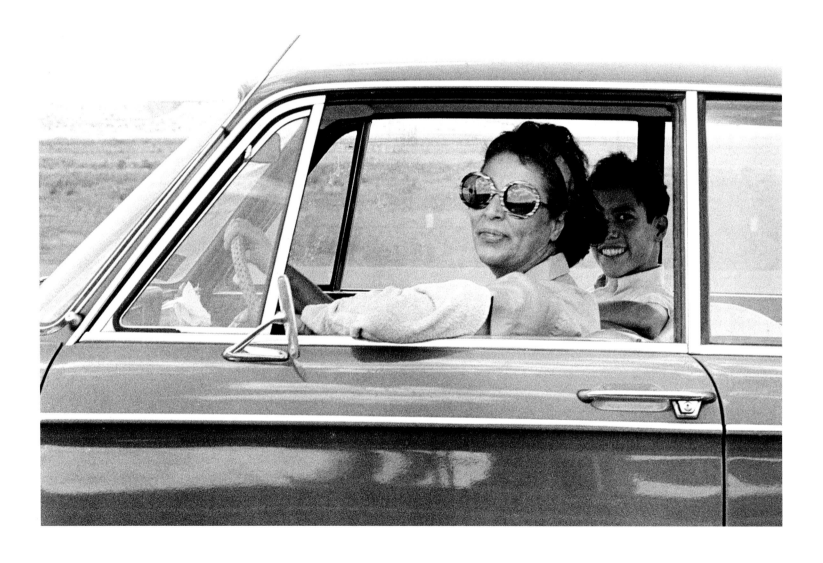

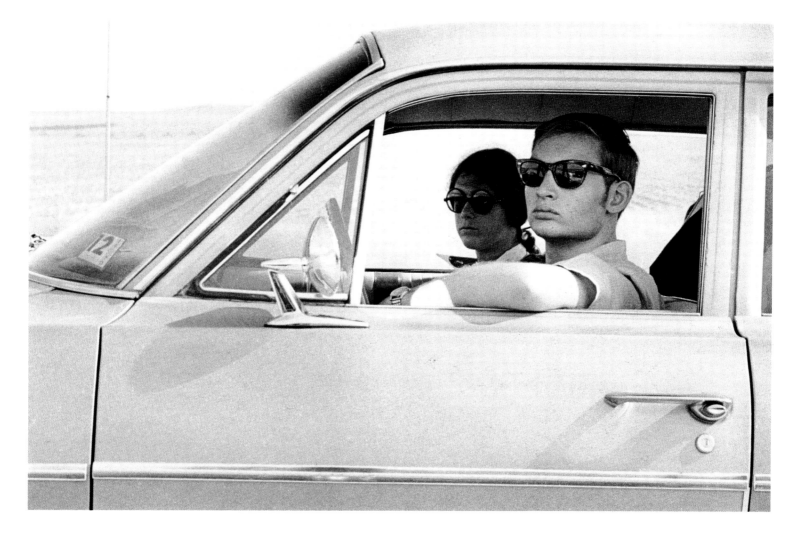

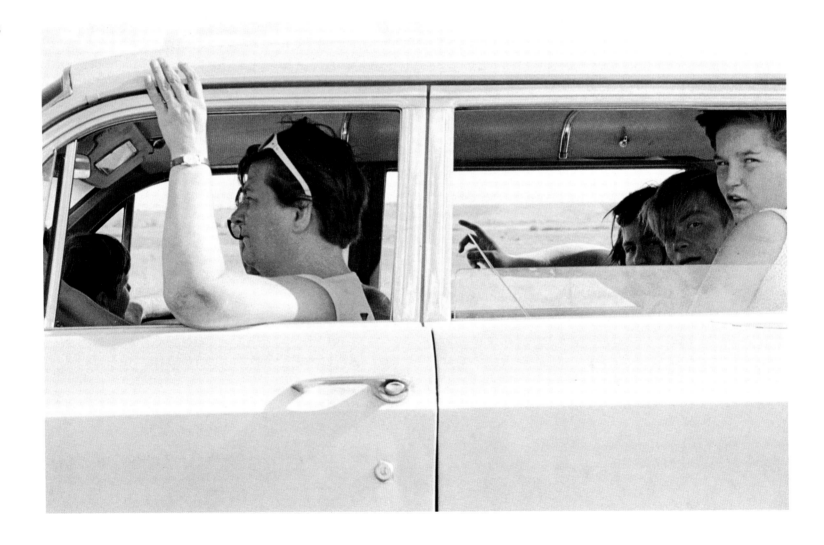

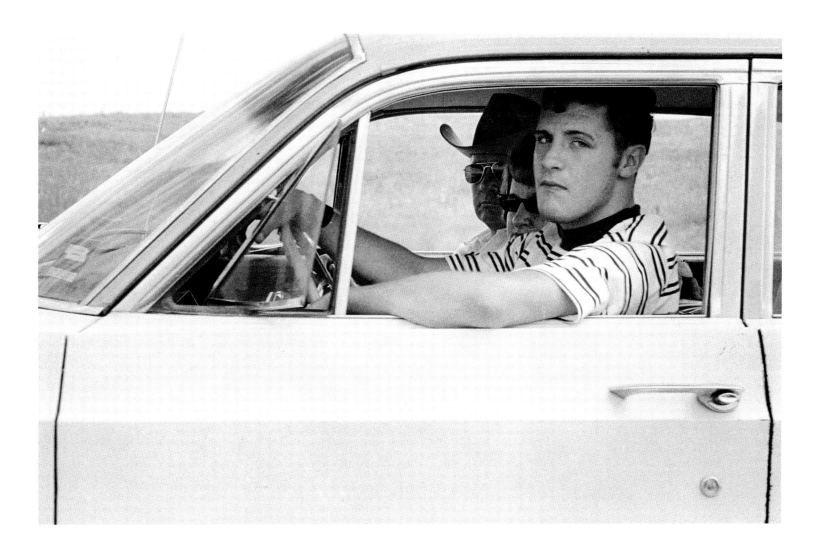

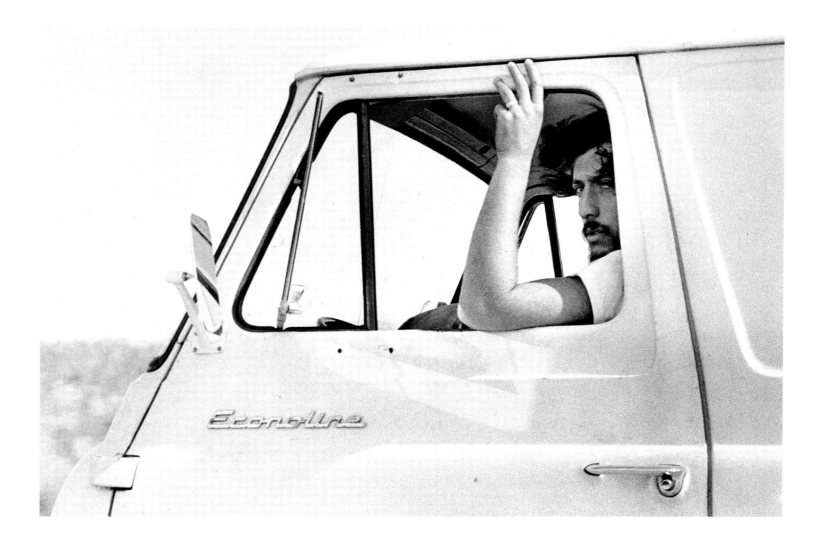

Two | COLLABORATION

I regard each of my best photographs as a trip I took into another country. I see in them elegance, dignity, and certain spiritual qualities that run deeper than any camera can see. They are as close as I can come to the heart of truth. For these things I take only part of the credit: I was simply there. The rest is collaboration. The eyes and whatever we mean by vision and sensibility were mine; but the dignity, the natural elegance of line and motion, the raw spiritual beauty that sometimes manages to struggle through belongs to my subjects.

As I work, the frame on the viewfinder makes its own demands and defines its own truth. I hold no particular prejudices. No format, focal length, or film is intrinsically superior to any other; each has its own merits, its own purely mechanical purpose. In certain situations, the 35mm format, the wide frame with its uncomfortable crowding at the top and the bottom, feels good to my eye; it fits the fugitive nature of my visions and dreams, gives me the necessary limitations to work well, and also provides the pressure I need to move ahead. At other times, I choose the ponderous 2¼ x 2¼ camera because its awkward slowness and unsettling detail force me into artistic decisions that seem to make a difference.

I avoid mechanical fetishes, but my whole being responds to the challenge of rules. To begin working, I set up a structured plan of action that includes parameters, lines of demarcation. Each time I pick up a camera and advance the film or slide a negative into my enlarger, these rules come into play. They bind and constrain and finally, by their very rigidity, give me the absolute freedom I need to create.

There are no accidents, no exceptions. I have trained my eye to respond to the action of the moment, to move into its rhythm and then to depict it in unusual ways. I have been accused of exploitation. I admit it. Always. But I accept the accusation as a statement of praise. Exploitation is never my aim, of course; but each time I focus the lens and expose a frame of film I know I am taking that step, going deep enough to exploit either my subject or, more often, myself. I reach out and take, or I am given: it is all the same.

I am a watcher, an observer. I am surrounded by a profound alone-ness, and this solitude forces me to listen constantly to my own mind and to trust my impulses.

No matter what the outcome, I refuse to pass through time unmarked.

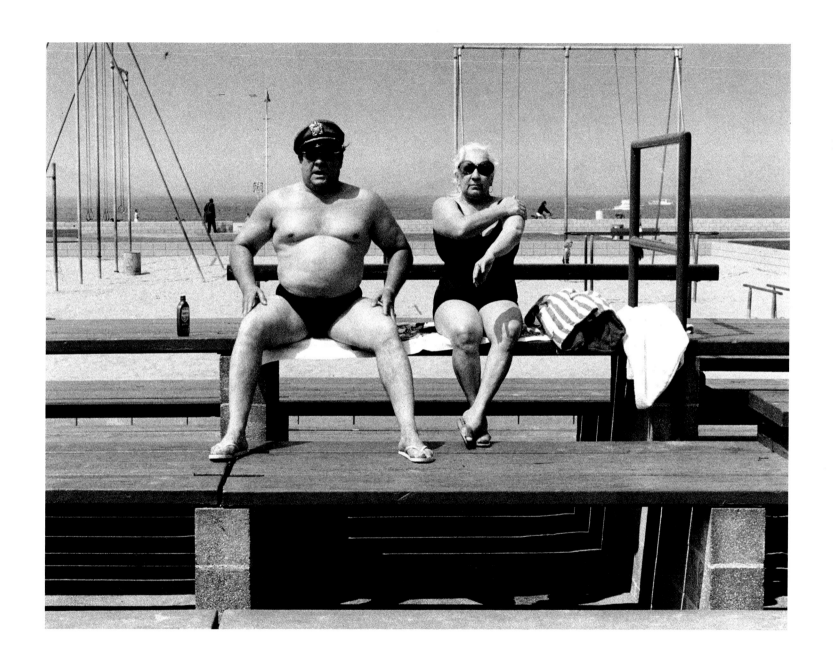

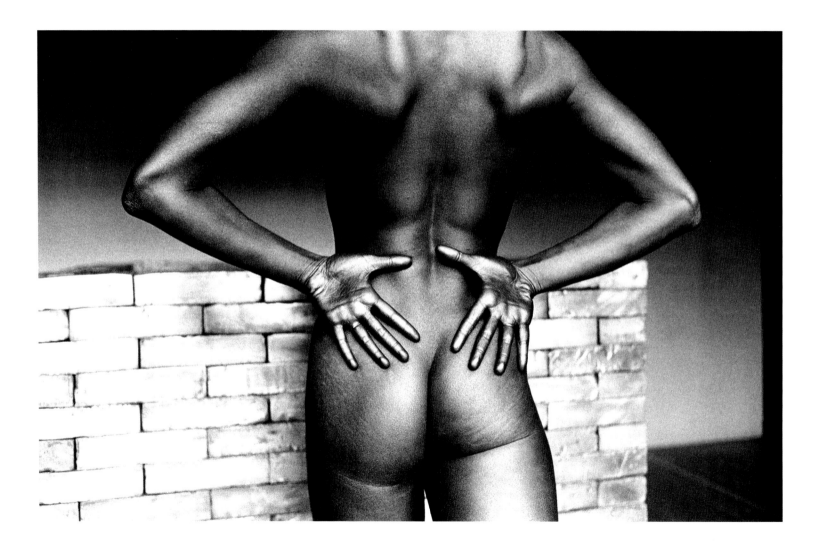

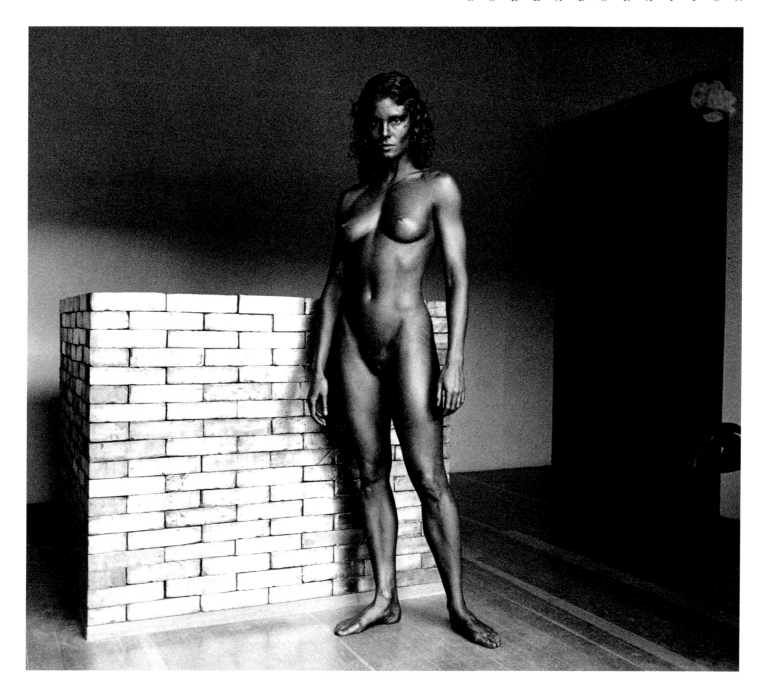

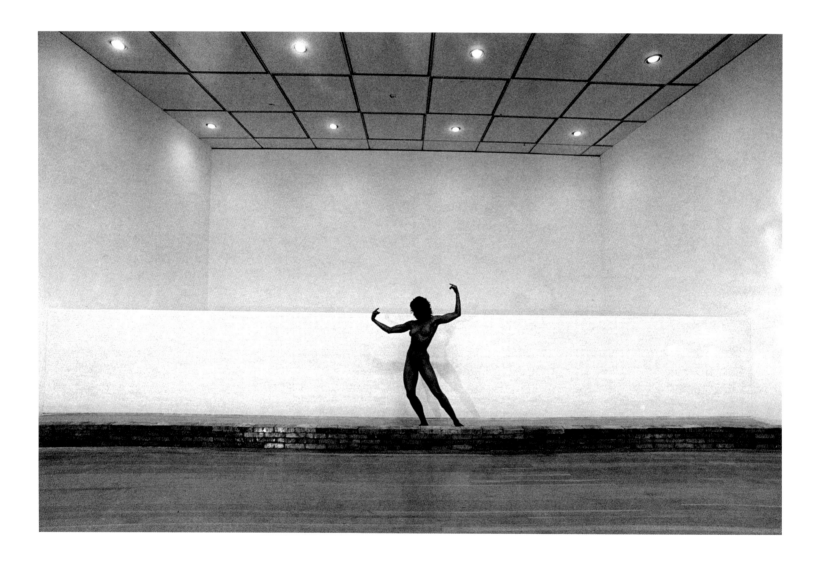

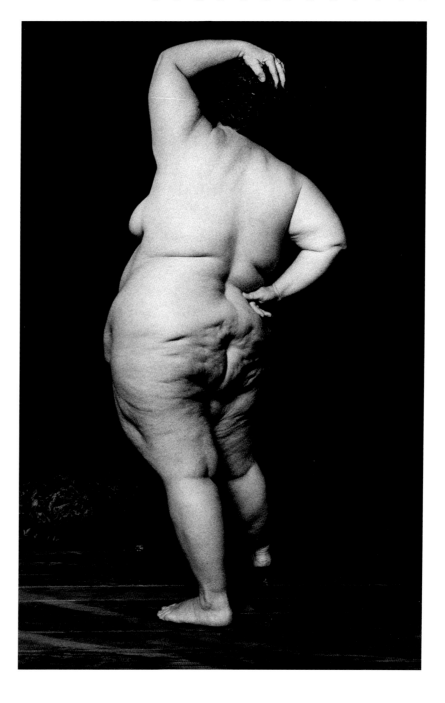

R E V E L A T I O N

Cameras. I like to think of them not so much as scientific instruments that duplicate the action of the eye to freeze an image on film but more as tools that enable me to perform real acts of magic. In fact, the closest I care to be to science is alchemy; and the only kind of technician I want to be is a shaman, a shaper of the sacred. I admit that these are romantic notions. But I am a romantic. And I hope I am incurable.

My attitude about the darkroom is similar to the one I have about the camera. I know in technical terms how light from the enlarger burns an image onto the sensitized paper and how the chemicals work variously to bring the tones of light and dark to life in the emulsion. But a knowledge of these things has never made printing a mechanical act for me. Each new photograph I see emerging through the developer's brackish wash excites me—I still reach out to help with the warmth of my fingertips, trying to clarify and define the image I see forming there. I treat every print as I would a drawing or a sculpture.

From the beginning, my interests have been primarily with people and the marks people have left on the earth. My first big series was on the great rock-and-roll stars of the 1960s. I shot them onstage, trying to catch the excitement of their performances, where I felt I'd find the truest picture of who they were. Only a few times did I risk taking my cameras into the dressing rooms. Partly it was because of my own shyness, but mostly it was because I felt their lives were far more ephemeral and fragile than they or anyone else would admit.

Since then I have worked with numerous groups of unusual people, including poets, bodybuilders, cab drivers, Indians, artists, convicts, cowboys, and border people. Almost always they were people living their lives on the margins of society, people on the edge. Then, I began accepting a few commissions for portraits. These came from individuals who knew my work and realized that, at best, we were collaborators in a chancey venture. They knew, too, that I was not a flatterer, that I was more interested in what might occur in the most successful of the images than in producing traditional portraiture.

In the commissions, as in all of my work, my initial move was to attempt to answer my own questions, to satisfy the impulse or turn of curiosity that first brought the camera to my eye. I believe that by concentrating upon myself in this way, by maintaining my center, I give the people on the other side of the lens the confidence to reveal who they are. For this reason, though I often carry a camera, I don't often use it.

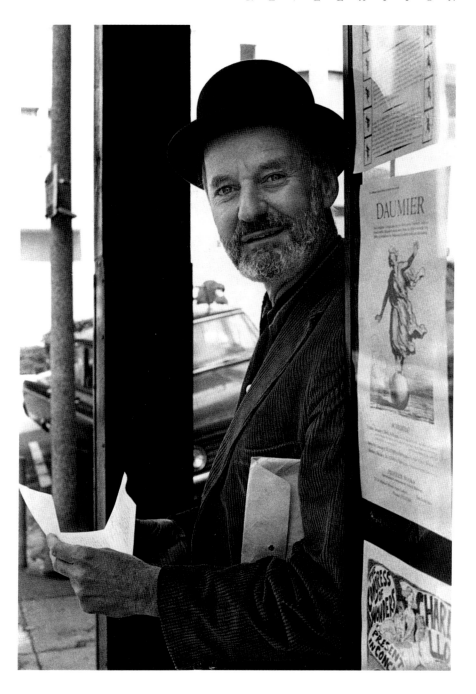

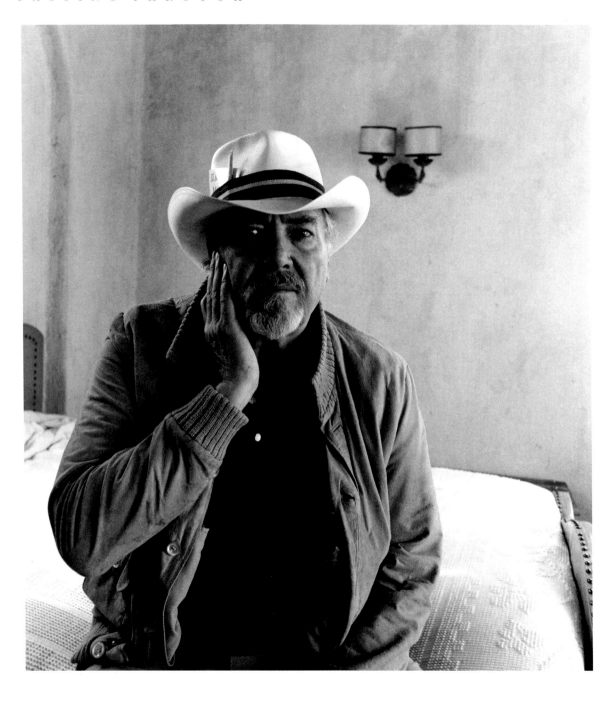

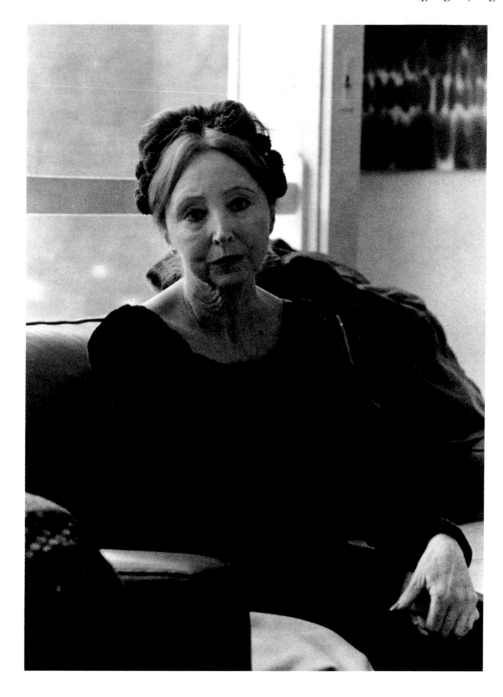

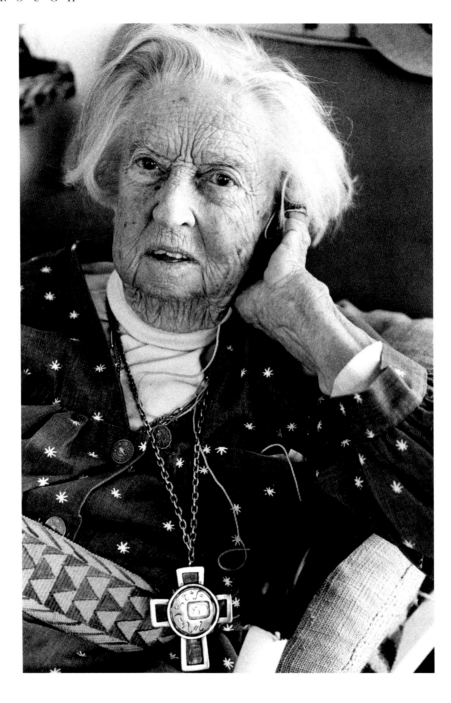

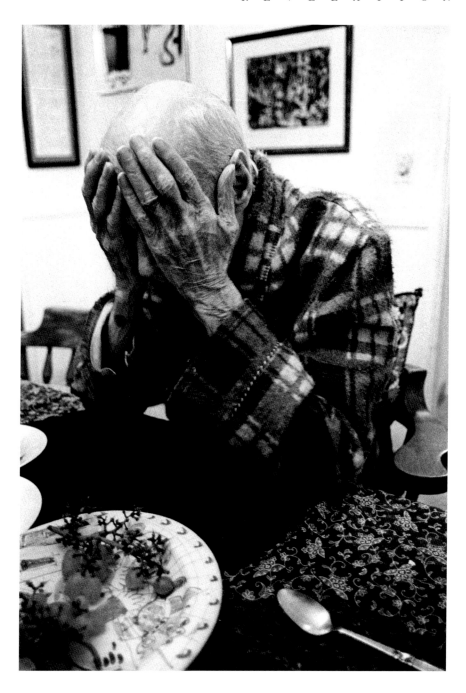

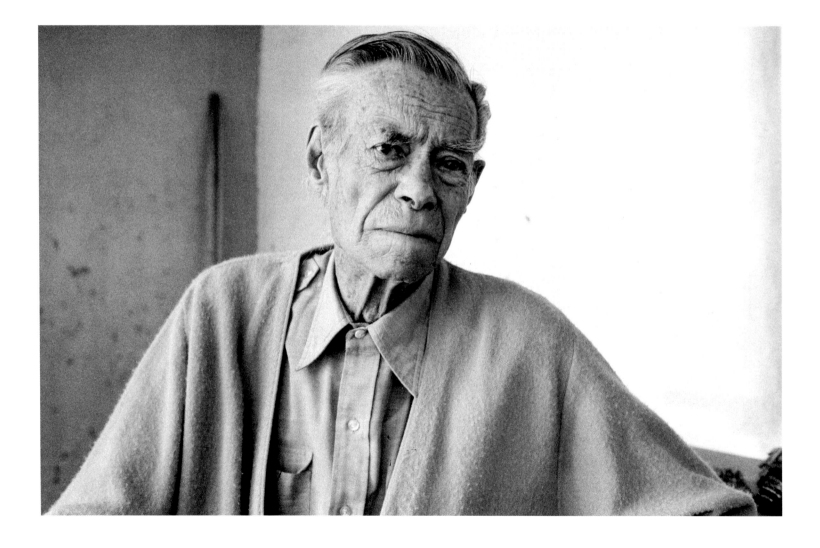

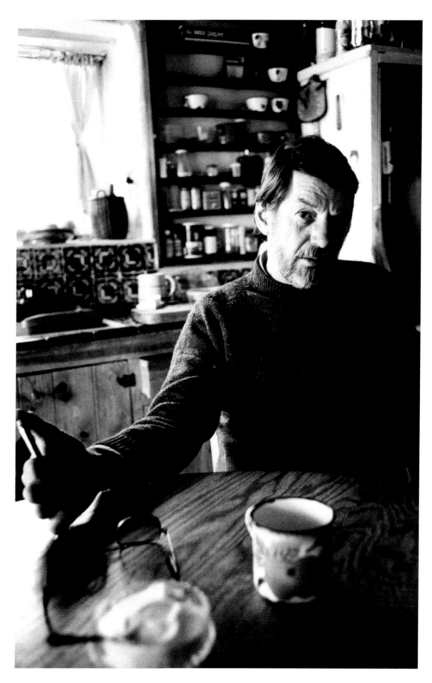

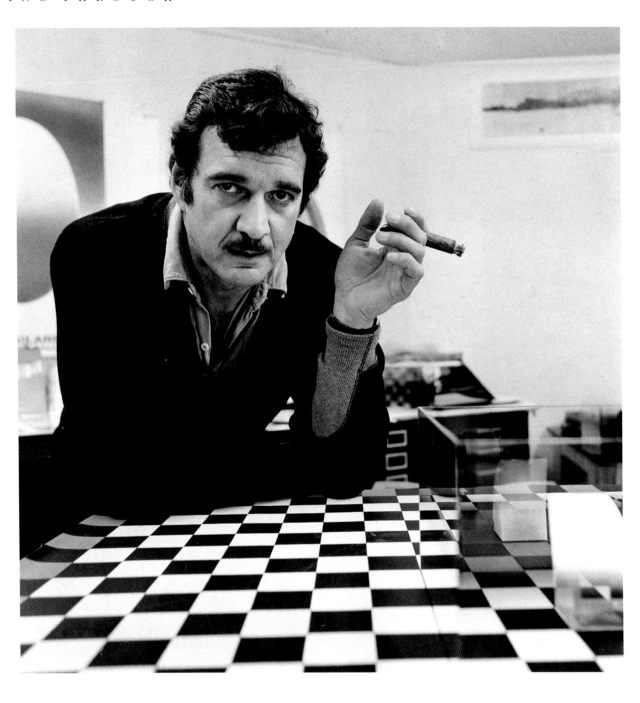

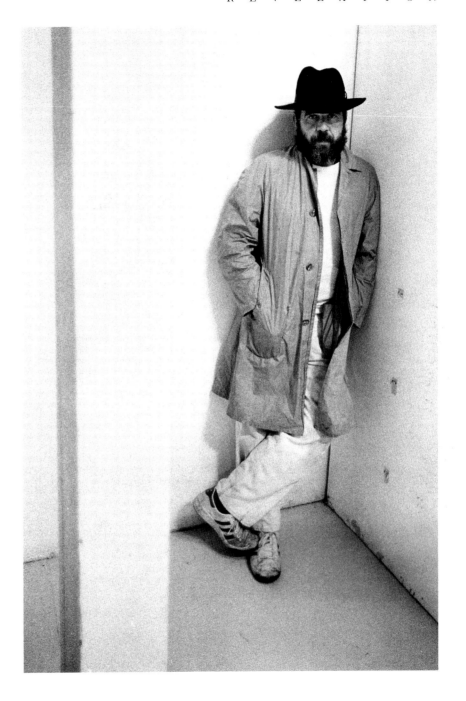

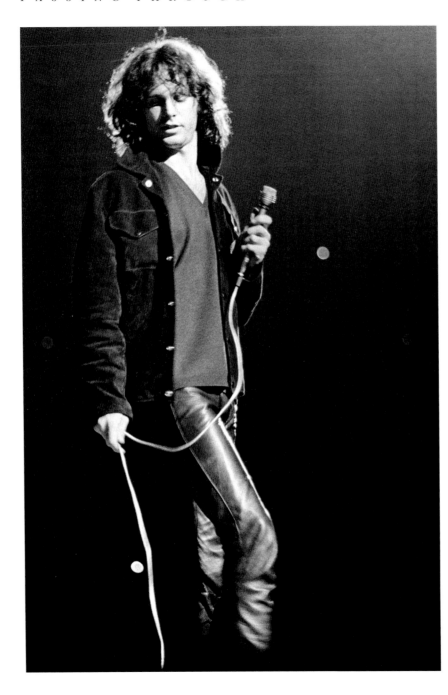

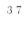

Four | S U S P E N D E D

Prison transported me far beyond the ordinary experiences of photography. Many times while I worked, I felt as if my equipment had disappeared, vanishing into the act of shooting the pictures, and all that remained was me and the convict, caught up in our frank dialogue. Those were electric moments, frightening in a strange puzzling way. As soon as I completed a day of intense shooting I immediately blocked out the experience and avoided thinking about it until I began developing the film. Then the entire experience would come back to me and I would find myself eagerly going over the strips of wet negatives, examining frame after frame in a state of suspended disbelief.

In a situation where everything is locks and keys, the men and women I photographed opened their lives to me in gestures of extraordinary generosity. Often we worked in their cells—not for the privacy but because they wanted to be photographed with the few real-life trappings they had managed to assemble, as though this in itself were a major achievement.

An editor once told me he thought the prison photographs ought to be rougher and more menacing. That is, of course, precisely the stereotypical and superficial approach I tried to avoid. My aim was to break down that barrier, to reach inside for the humanity I felt the convicts were struggling to show me: Look, they seemed to be saying, I'm a man; I'm a woman. Part of the enormous sorrow I felt during the years I worked on this series is that the humanity of the convicts does come through—in painful juxtaposition to the situation of their lives.

In prison, the idea of Passing came together like the bolt and plate in a lock. The perverse power I found inside the walls grew until it might have been the hum of a huge motor. There were strange rhythms alive in each of these places. Everything seemed more clearly defined than in any normal situation, more black, more white, with harder edges. I came face to face with violence, hatred, egoism, fear, ugliness, brutality, and a bizarre kind of beauty. There was an intense organization to prison life, and yet, on a certain level just beneath the surface, everything was out of control, totally haywire and crazy. And I realized, as I had with the people in cars, that the convicts, too, were people suspended in space, doing time, passing.

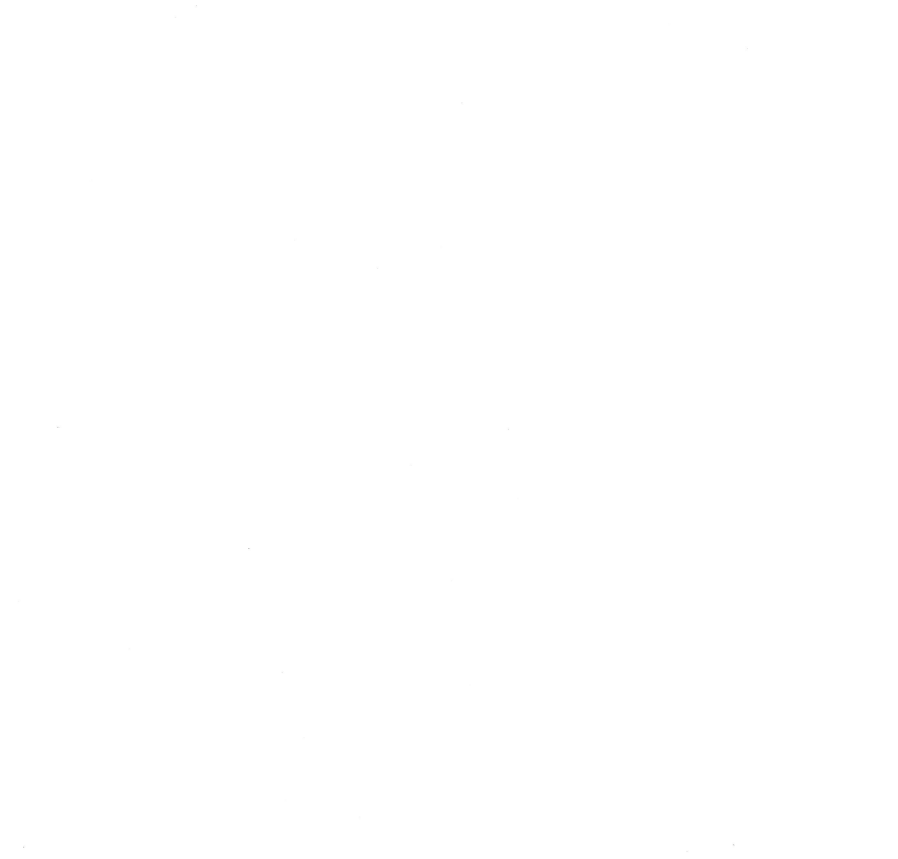

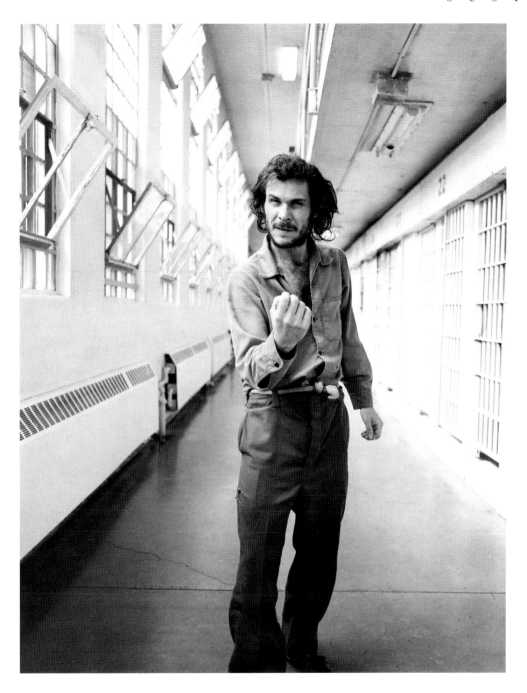

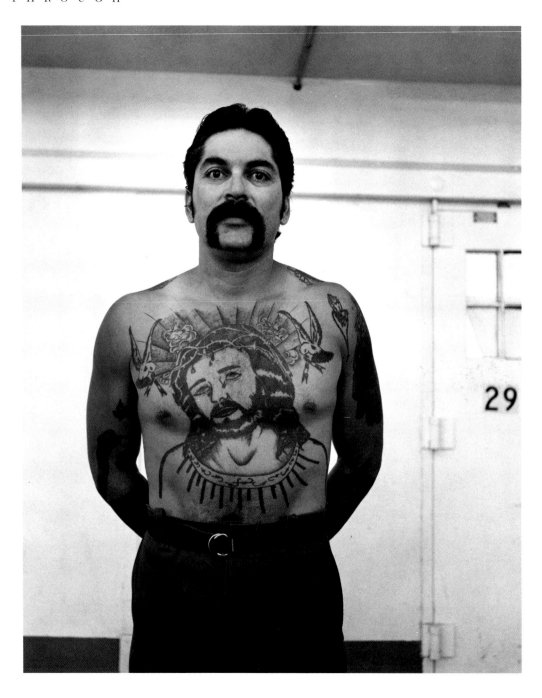

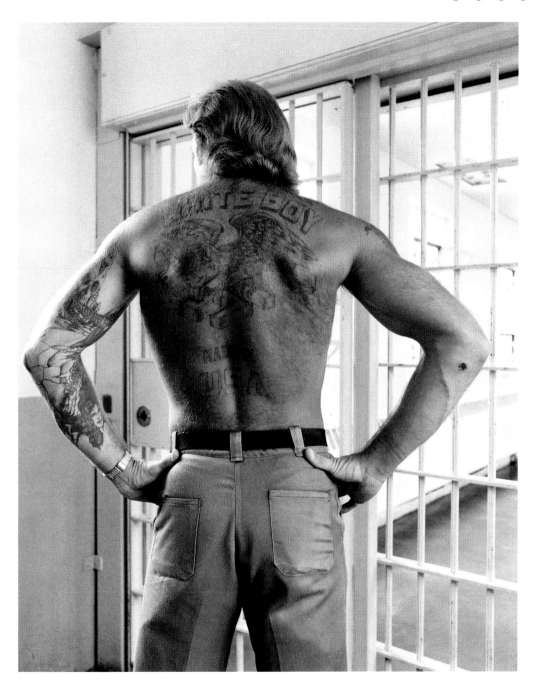

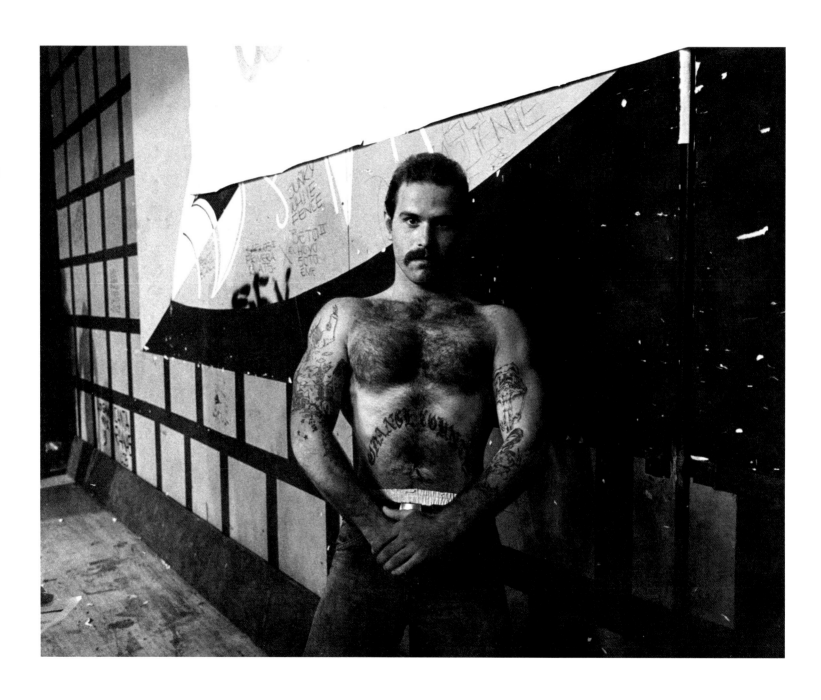

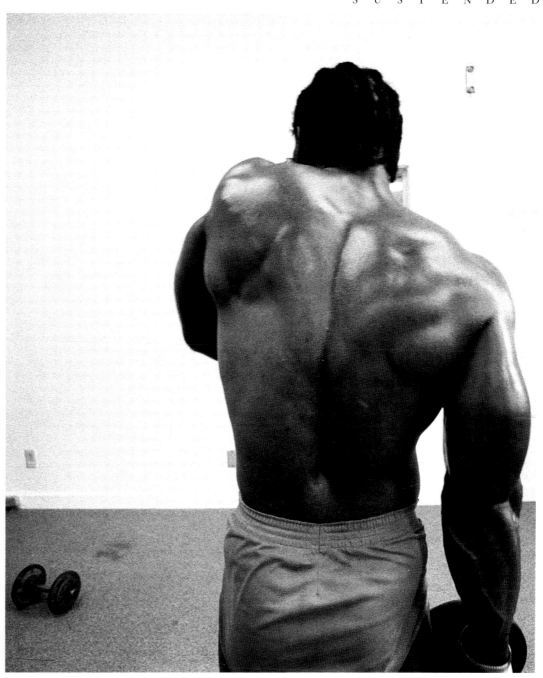

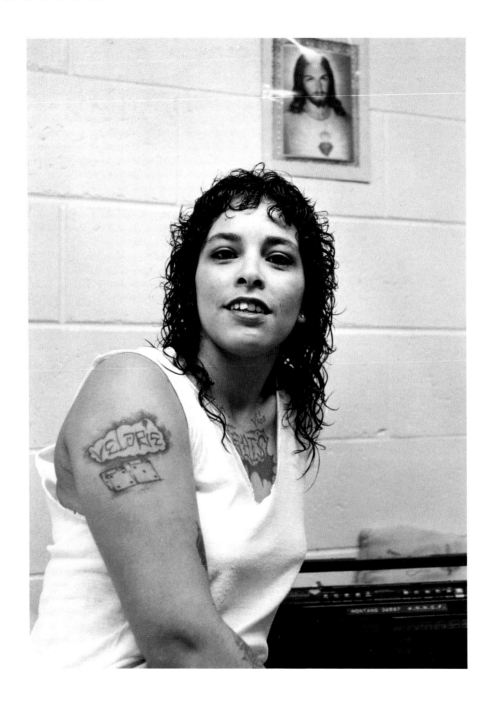

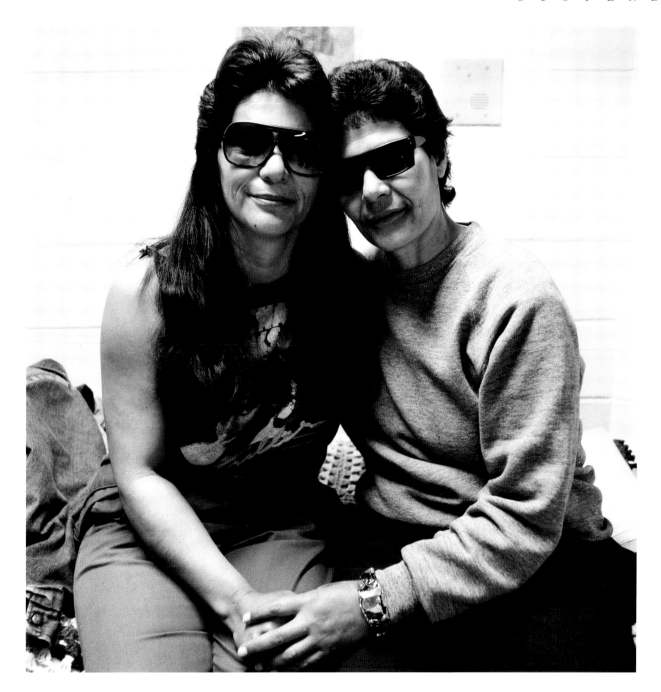

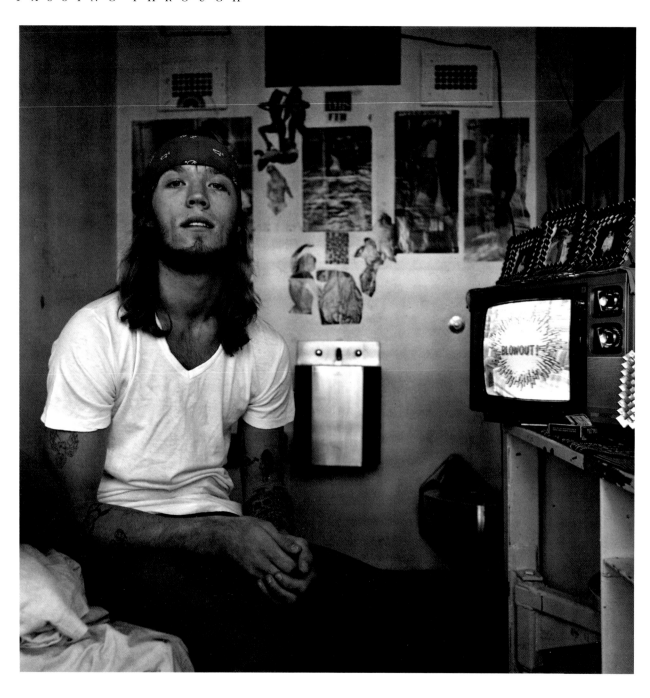

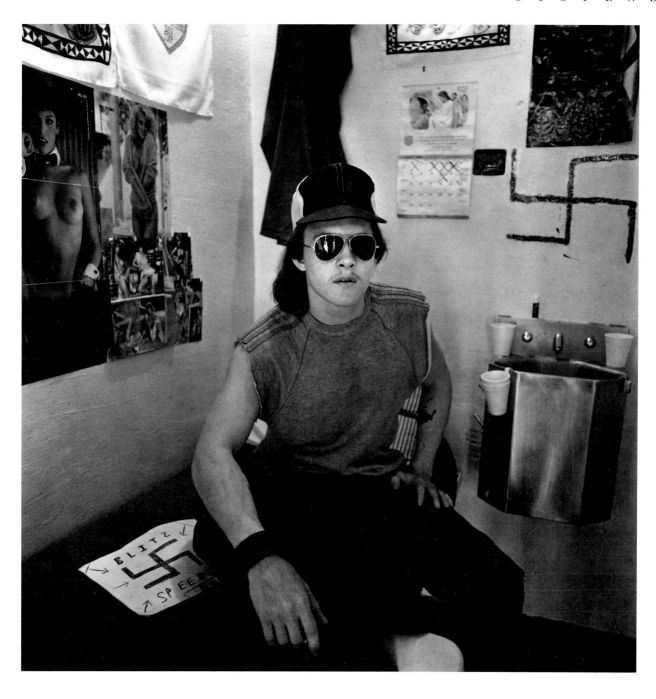

Five | # CONFRONTATION

The image was there long before my first hat or my first pair of boots; it pre-dated my bull rope and bareback rigging, my saddle and the other paraphernalia necessary to a teenager's singularly undistinguished foray into rodeo; in fact, it was probably always there, the image of the cowboy, an exaggerated imprint tucked away in some special part of my unconscious.

So, in a way, shooting cowboys became a kind of balancing act for me, a way of walking a high-wire through a clutter of personal fantasy to end up with the real thing. The most accomplished of these authentic hands are proud, shy men who measure up in every way to the legend they perpetuate. In the likeness of each good cowboy I shot, I could map the brief but explosive history of the breed and trace it back to its beginnings on this continent.

When I took my cameras to the rodeo arena, there was a simple, direct confrontation that, like flint on steel, produced a spark. The best photographs resulted in a pure crystalline image, an essence complete and perfect. Sometimes it was only a fragment. For example, while photographing a group of young cowboys in Mesquite, Texas, I shot only their boots, and this single frame came to somehow characterize my style.

Later, photographing the cowboys for my book, *Working Cowboys*, I found that a spur, full of its possibilities as a tool and as decoration, said as much about certain men as was needed.

Too many times I've heard the statement that a picture is worth a thousand words. There may be truth in it, but I prefer the picture that has all the pithy qualities of a poem. In fact, I believe the best picture has an eloquence without words. I want it to stand before me and leave me speechless.

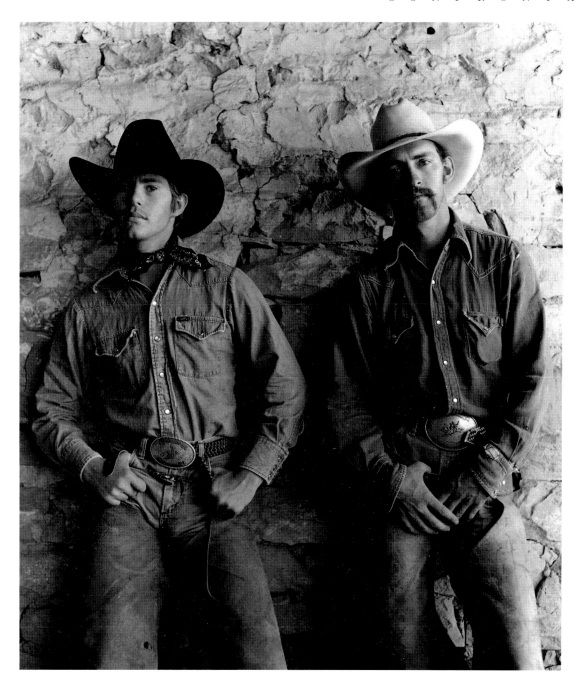
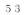

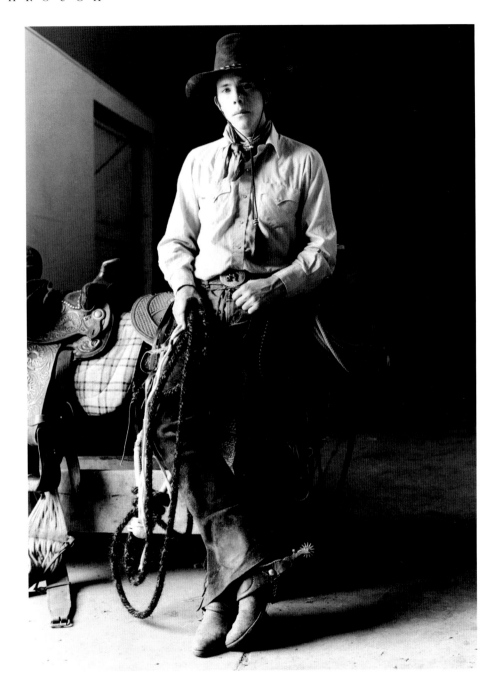

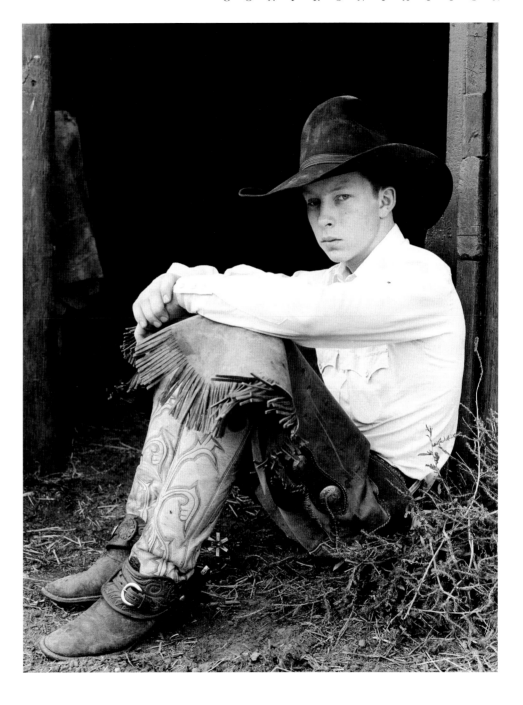

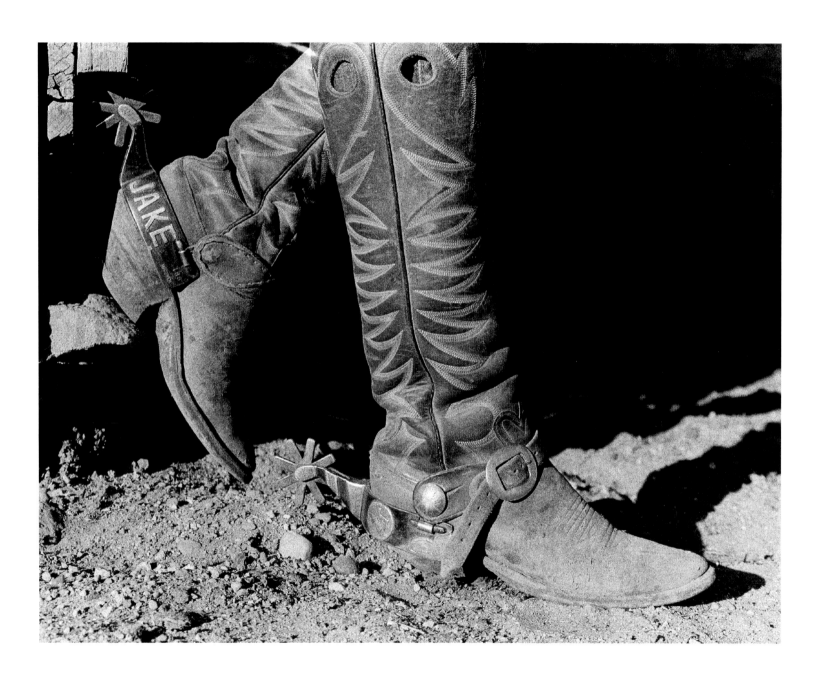

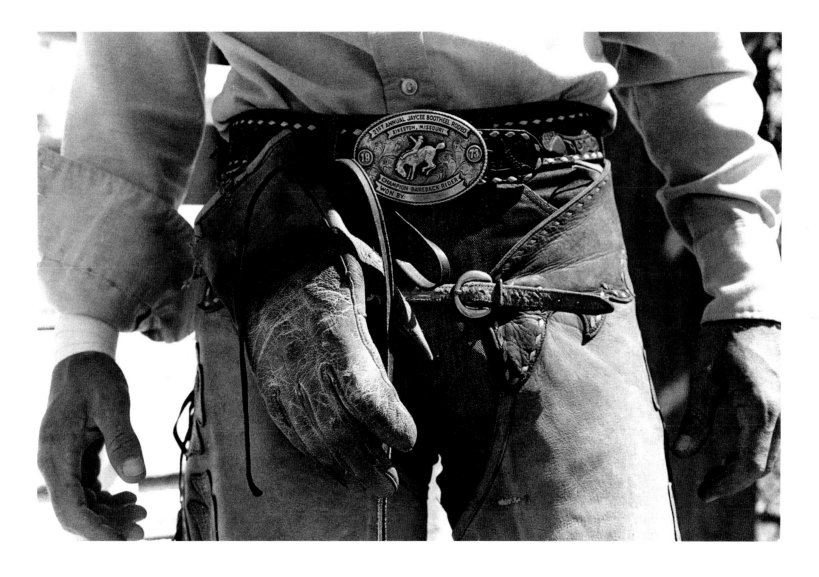

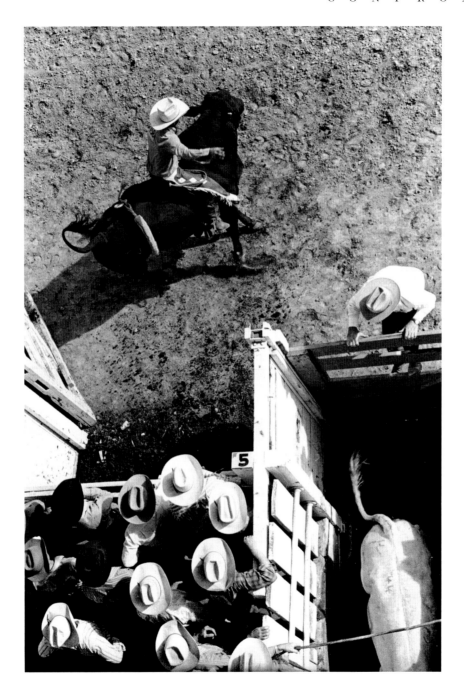

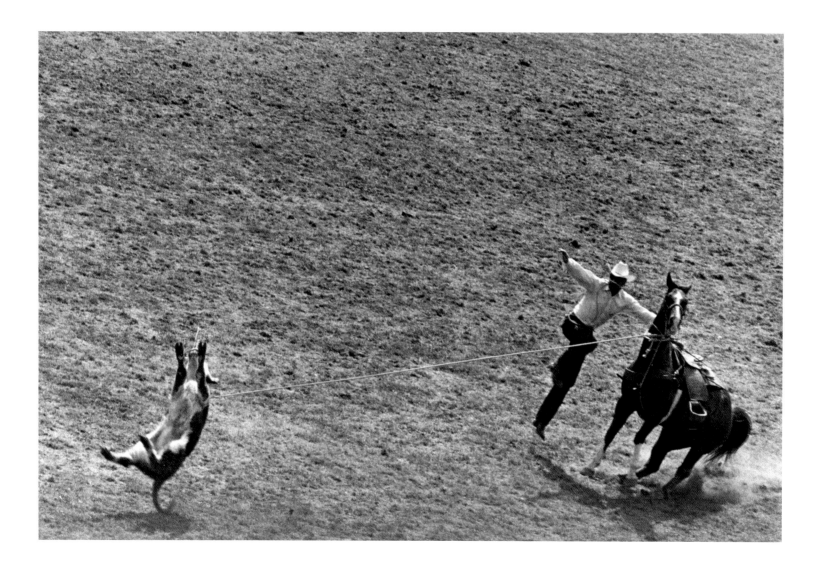

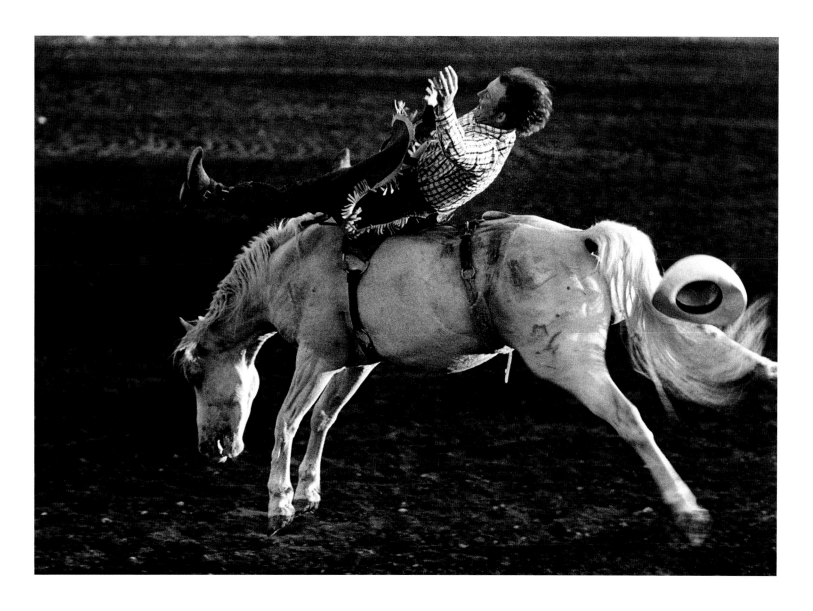

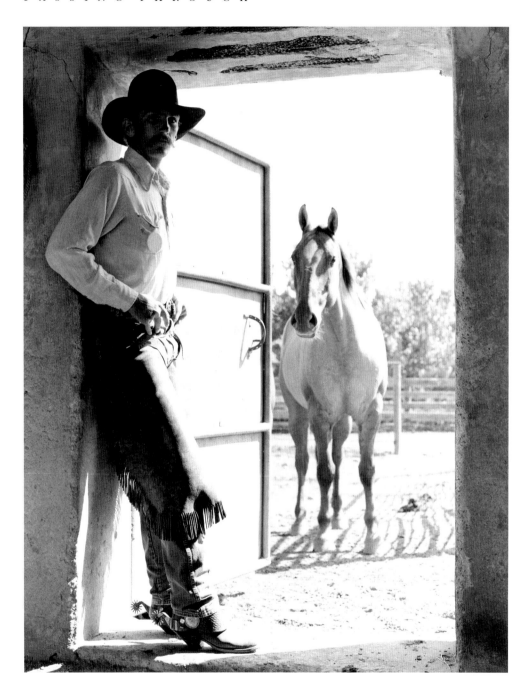

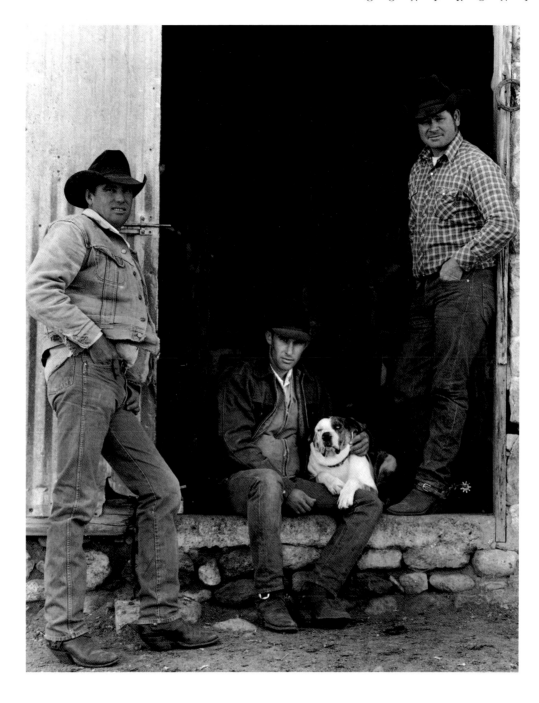

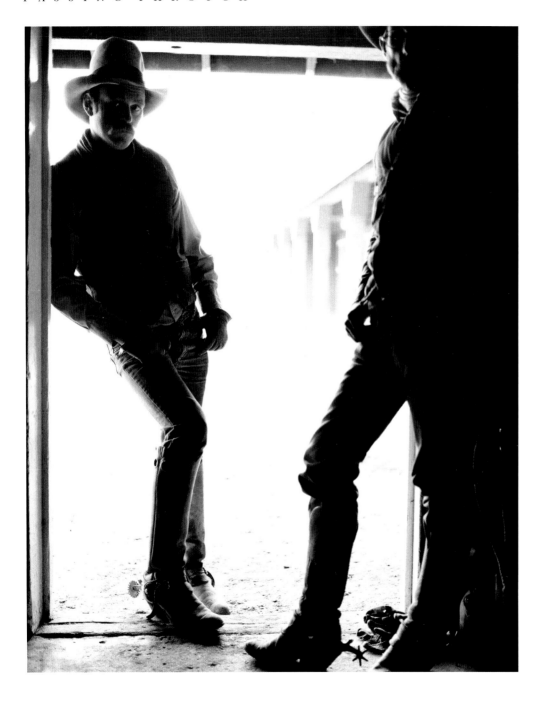

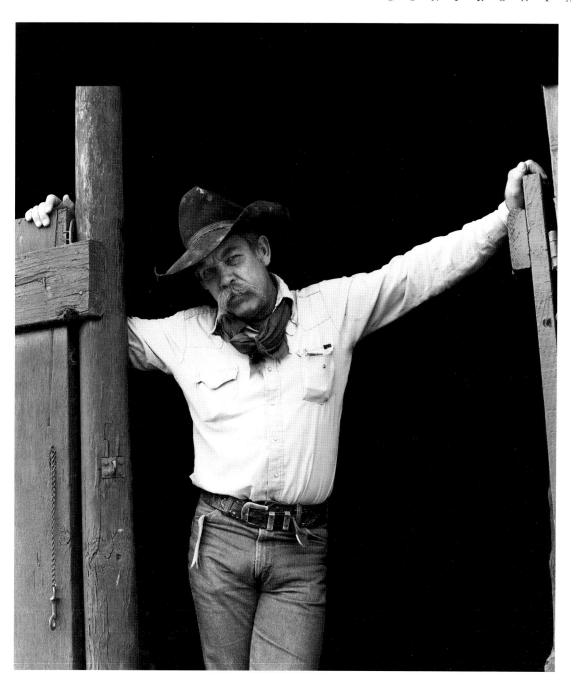

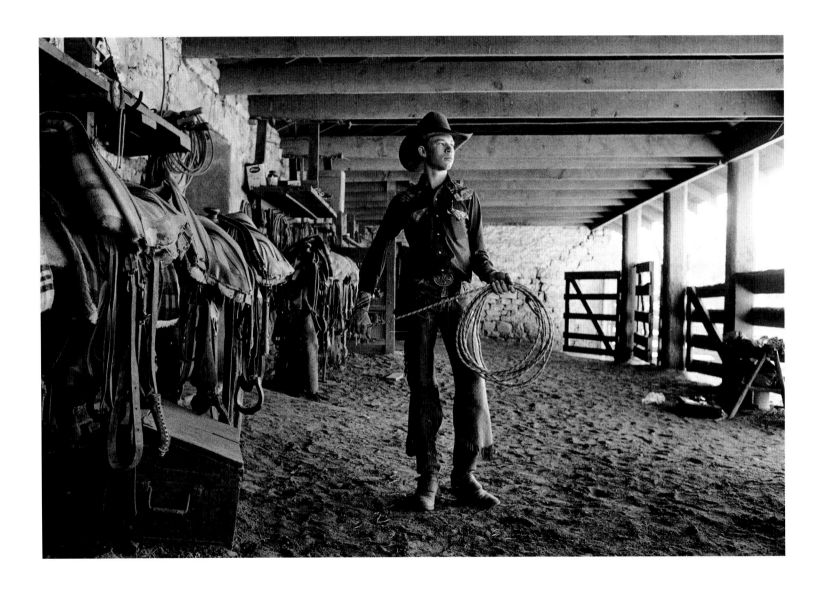

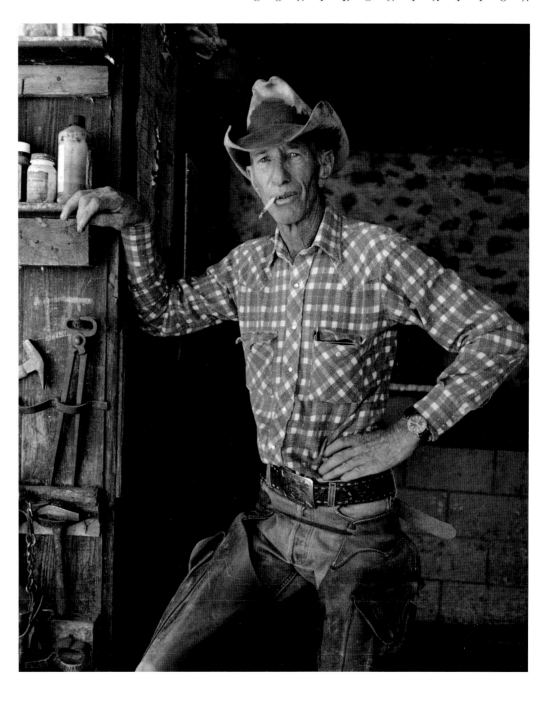

Six | E N I G M A

The border between the United States and Mexico is another country. During my travels there, I came to see this area as a strange psycho-physical warp belting the continent, a geologic formation of mind and matter that was continually faulting along this sinuous fracture line. The elements exist in layers, a complex panoply of greed, love, hate, and pain in a landscape that is at once beautiful and ugly. These are strata that have formed from the filtering-down of the debris of centuries. No matter how many of these layers I tried to peel away in the act of photographing the border, I was always left with the puzzling fact that I could never quite get beyond the mystery of this strange, exotic region. The longer I was there, shooting frame after frame in an attempt to document and record on film what I saw unfolding around me, the deeper I found myself slipping into the tantalizing enigma of border life. And I believe this is, in the end, what has finally solidified and lent form and dimension to these photographs.

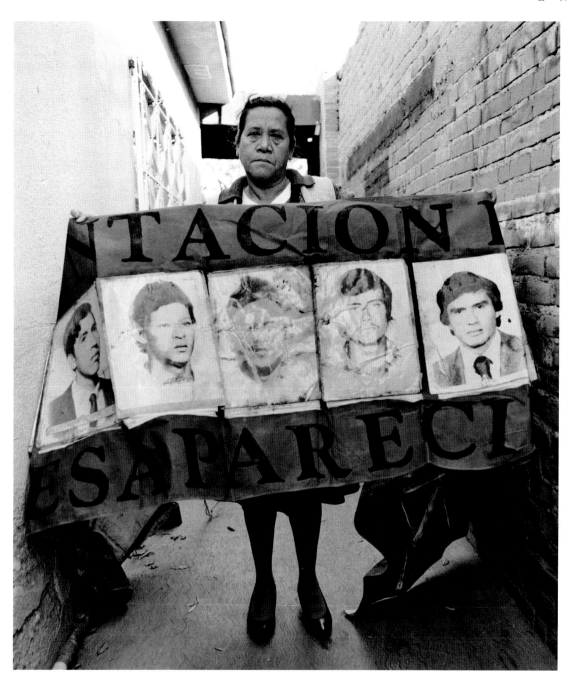

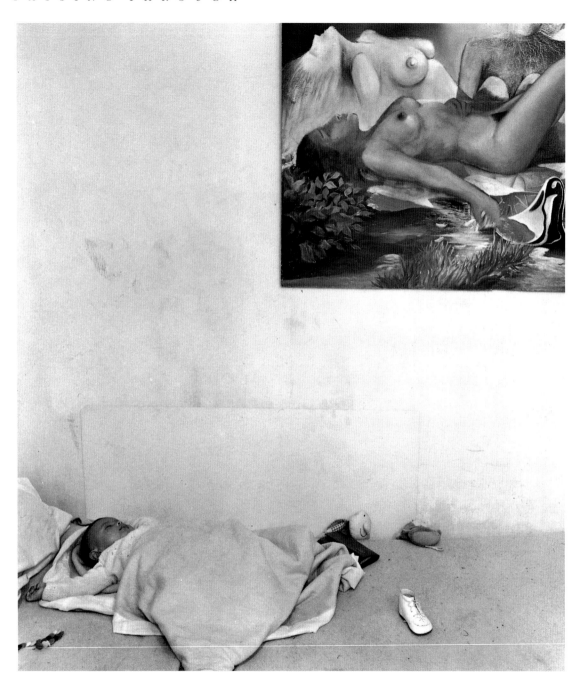

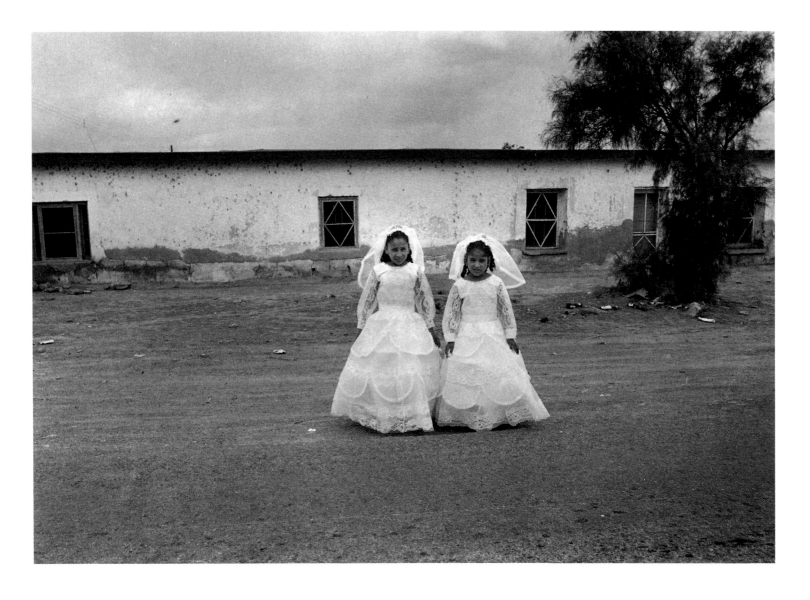

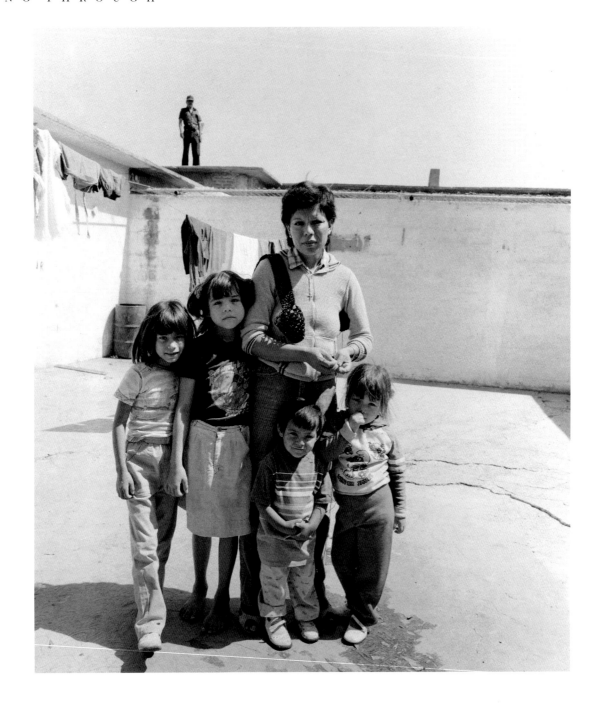

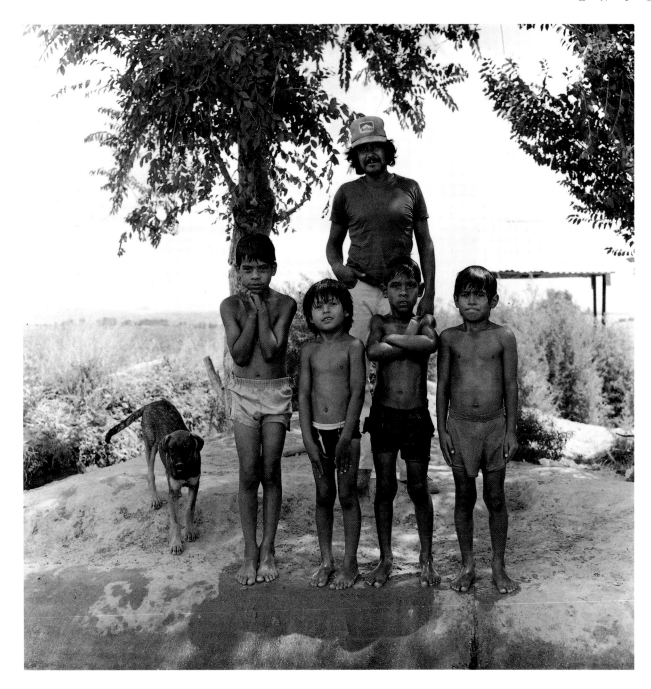

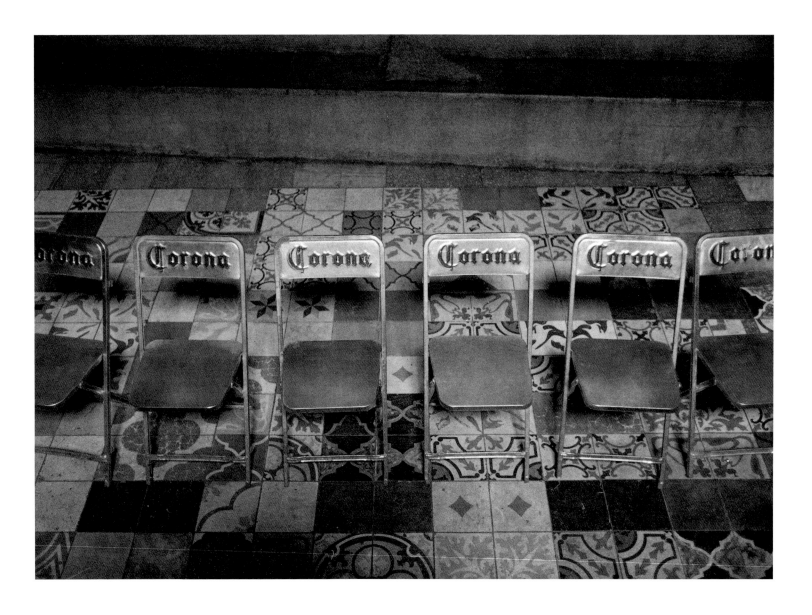

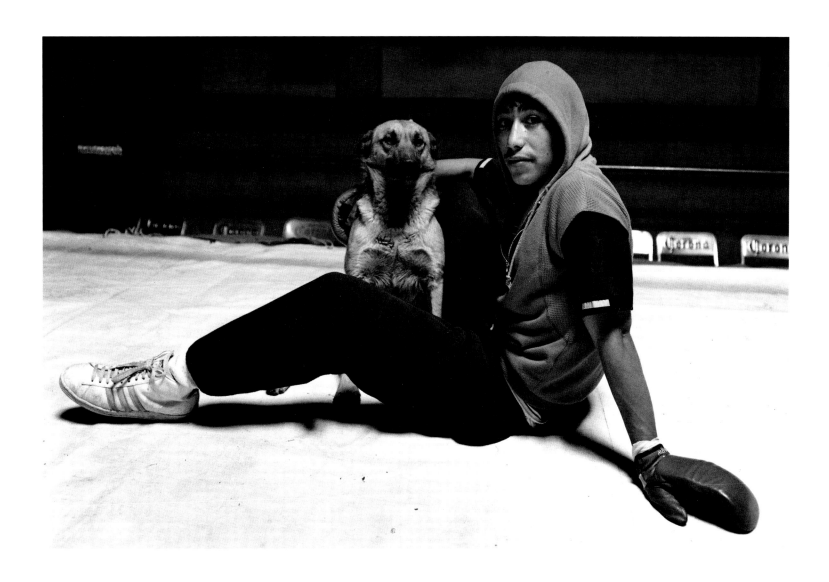

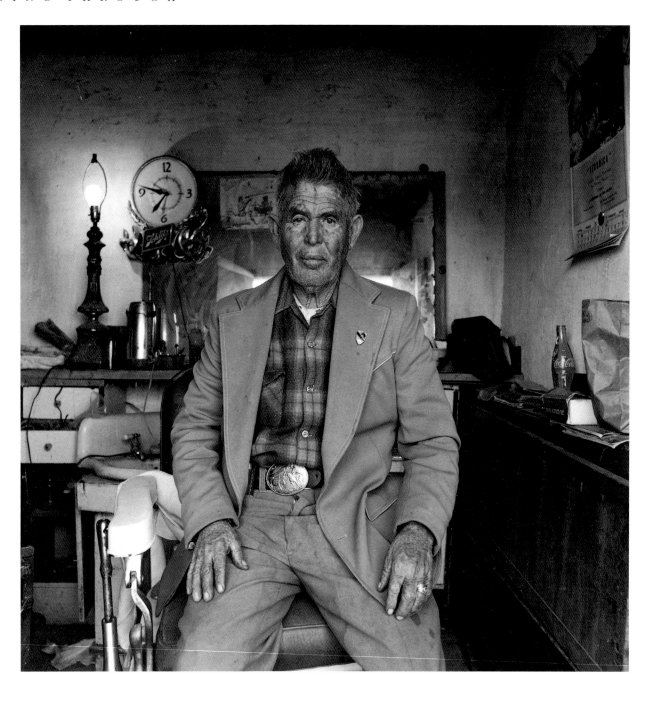

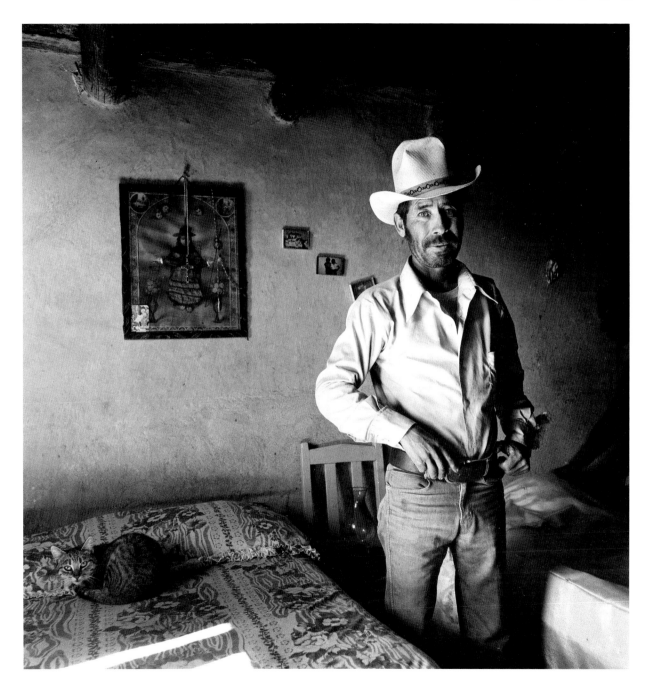

MEDITATIONS

I was seventeen when I discovered Lao Tzu's *The Way of Life*. The simplicity and depth of this old master's insights suggested new ways of looking at life: "When all the world recognizes beauty as beauty, this in itself is ugliness." In the thirty years since then, I have, with no conscious pattern or motive, continued to read and reread various Oriental authors. Out of this study has emerged a goal: to teach myself to use a camera with both the swift conviction of a samurai wielding his sword and the clarity that comes to a priest when he realizes his mantra.

Recently, I discovered the works of Zen Master Eihei Dogen. Certain of his statements reinforced ideas that had been taking shape in my own mind for as long as I'd been concerned about my relationship to the world. Where I feel this influence is most evident is in my landscapes, especially in the body of new photographs I call Meditations, the first series of which is "The Green Aspen Meditations."

There are no direct correlations between Eihei Dogen's words and any of the photographs. The words are one thing, the photographs another; they are separate, distinct, and complete in themselves. However, the following are passages from Dogen's writing that kept surfacing in my mind during the time I was shooting and printing "The Green Aspen Meditations":

There are mountains suspended in form: there are mountains suspended in emptiness.

An ancient buddha said, "Mountains are mountains, waters are waters." These words do not mean mountains are mountains; they mean mountains are mountains.

To say that the world is resting on the wheel of space or on the wheel of the wind is not the truth of the self or the truth of others. Such a statement is based only on a small view. People speak this way because they think it must be impossible to exist without having a place on which to rest.

The nature of wind is permanent; because of that, the wind of buddha's house brings forth the gold of the earth and makes fragrant the cream of the long river. Each moment is all being, is the entire world. Reflect now whether any being or any world is left out of the present moment.

You may suppose that time is only passing away, and not understand that time never arrives. Although understanding itself is time, understanding does not depend on its own arrival.

Know that there are innumerable beings in yourself. Also there is birth, and there is death.

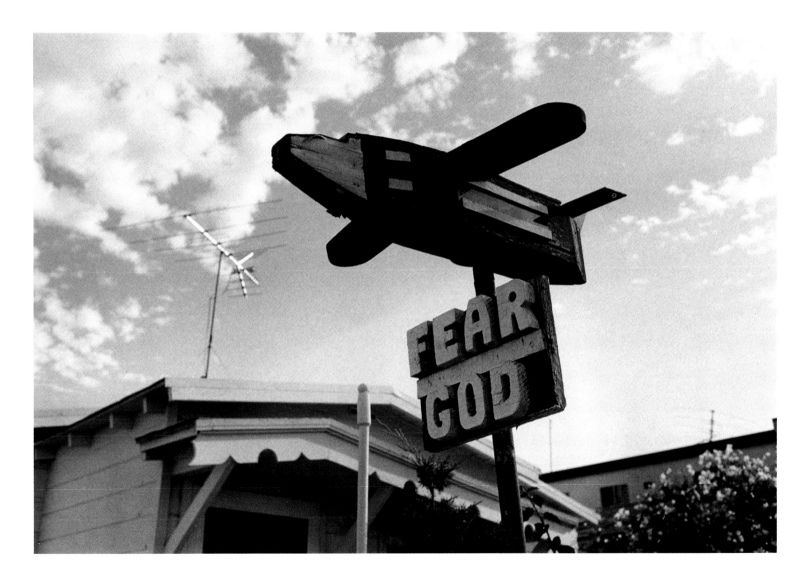

84

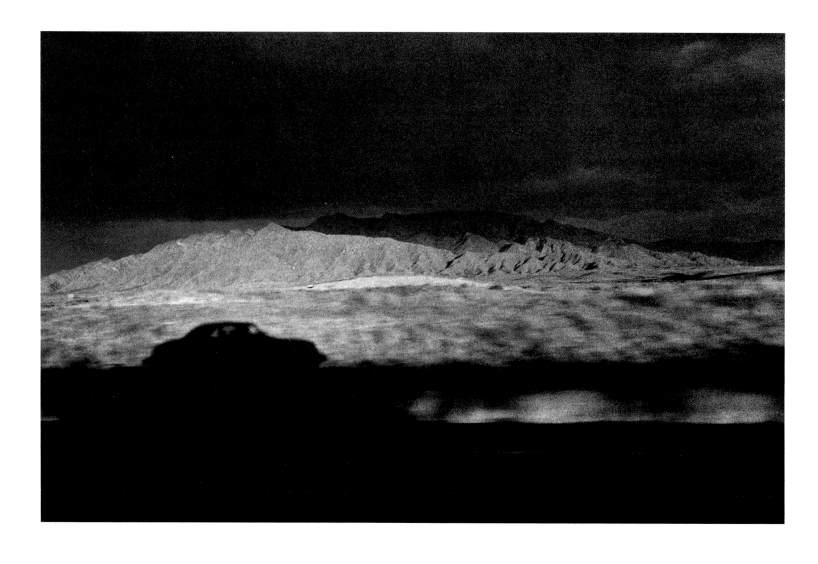

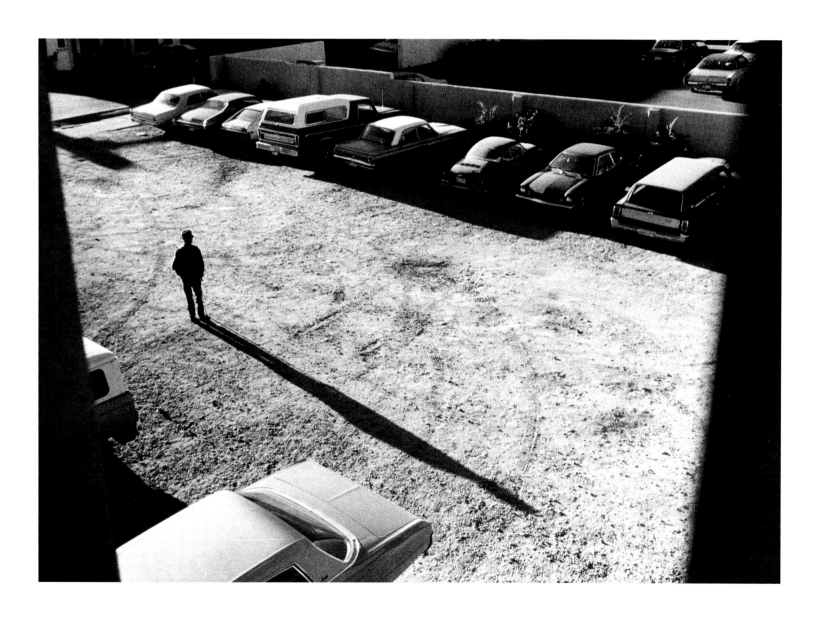

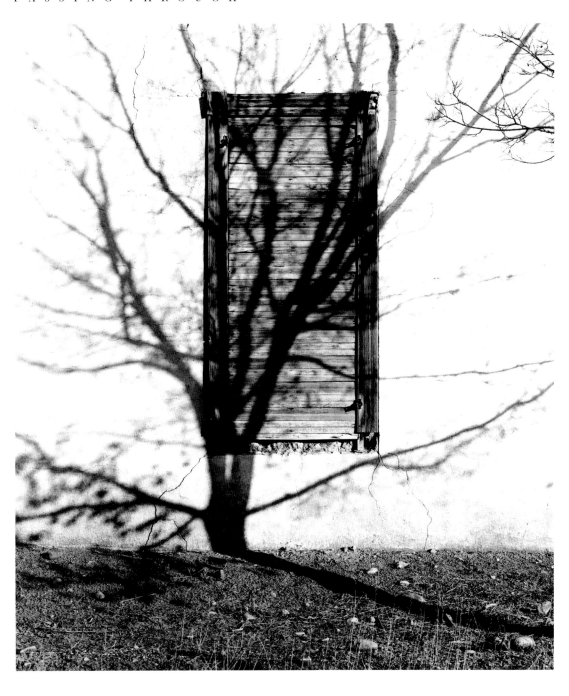

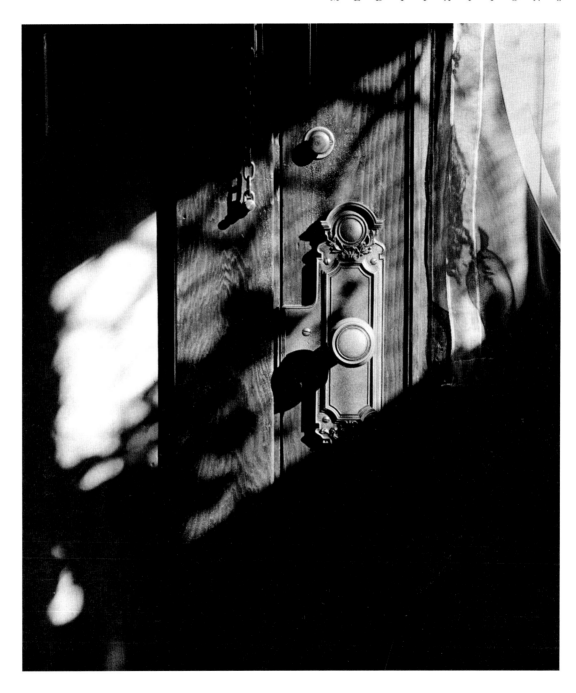

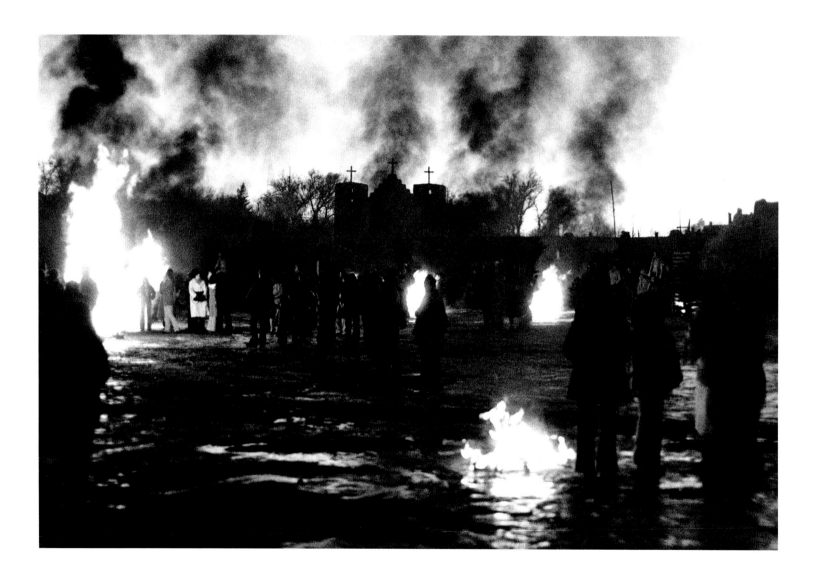

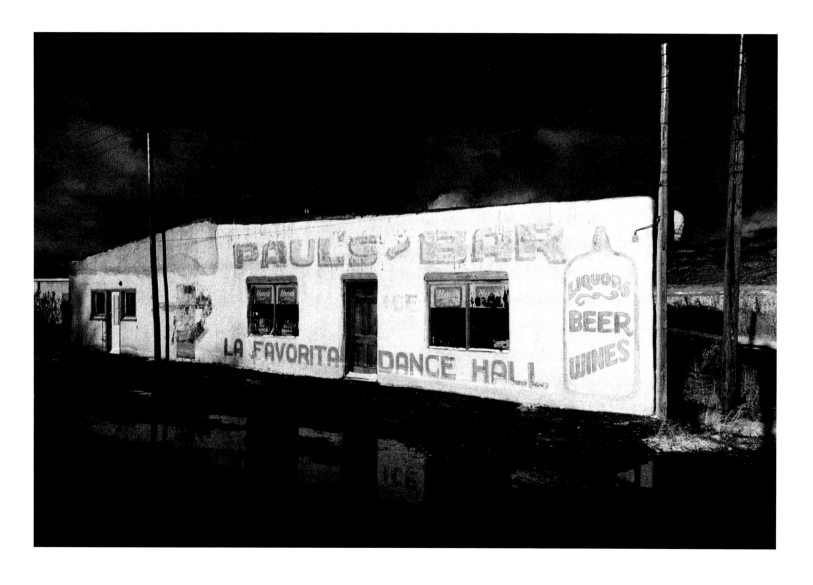

Eight | S I L E N C E

Too often we see history only as it touches and somehow protects us. We memorize the facts and embellish them until they become a line that ties us back to God or some fixed and certain heritage to which we hope to tether our souls and keep them from being set adrift in something as vague and unsettling as universe, galaxy, and the mysterious beyond. What changed that view for me was working among Indians.

More silent and austere than any of my other images are the photographs of the Utes, Navahos, Pueblos and Hopis I made in 1969 and 1970. It would be presumptuous of me to say those qualities exist in the photographs themselves; but I know painfully that they were a part of the experiences of shooting them. I confronted the whole history of the exploitation of the American Indian and learned a new meaning for sadness and waste.

I had lived near Indians all the years I was growing up; they were merely an ignored, almost invisible part of the landscape of my youth. It wasn't until I returned with my cameras after having lived in London and New York, where I had begun to learn a new way of looking, that I really saw who they were. Then, when I had those faces in focus on the ground-glass inside my viewfinder, I started to read my way into their lives and began to realize what it meant to have a history, to persevere. I saw a culture in which there was no separation between life and the laws of life. I met a people who could touch the earth and see in it more than a handful of dirt.

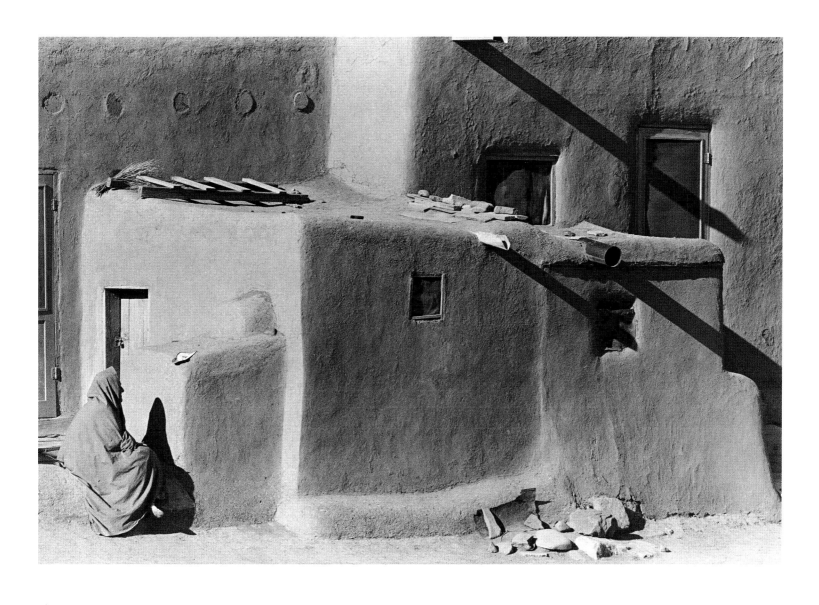

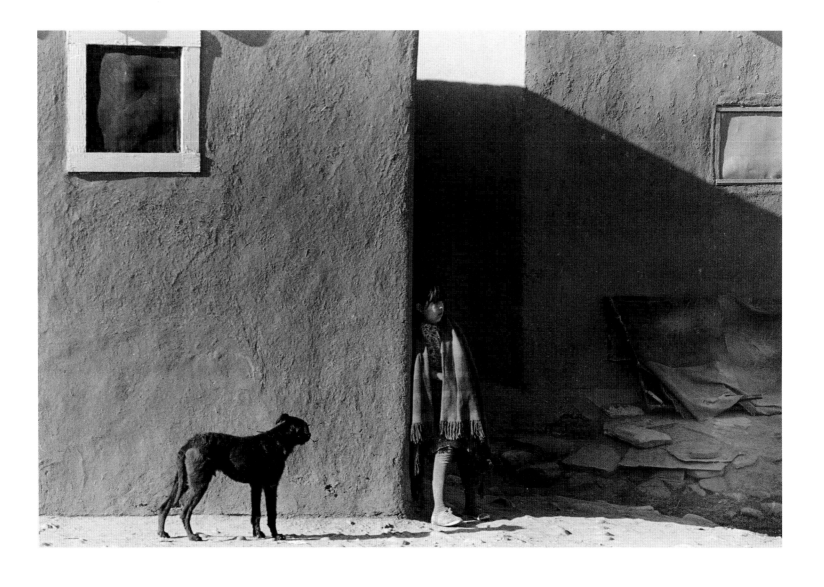

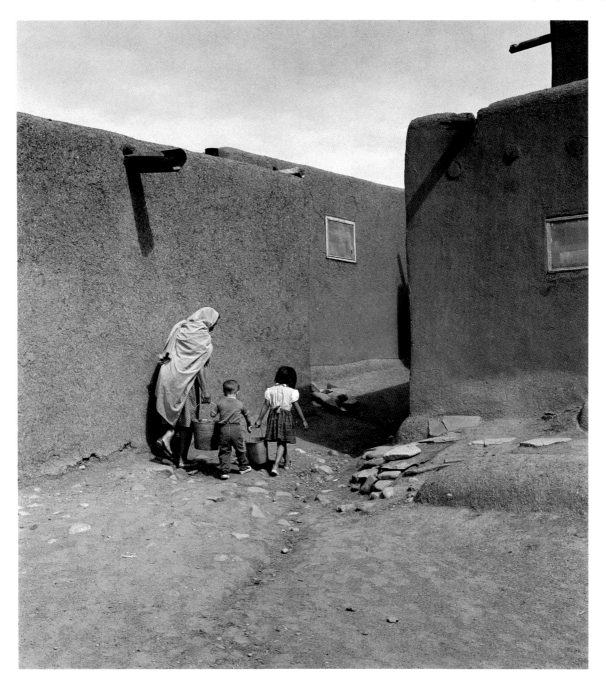

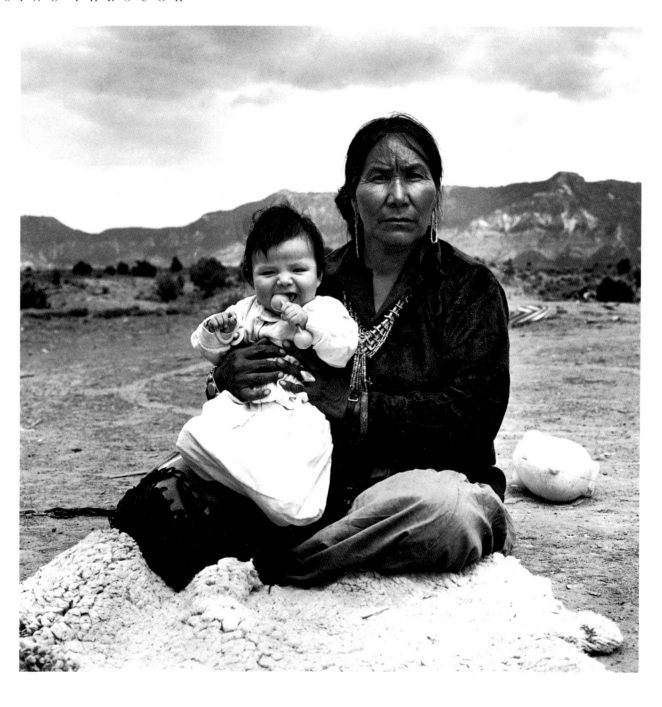

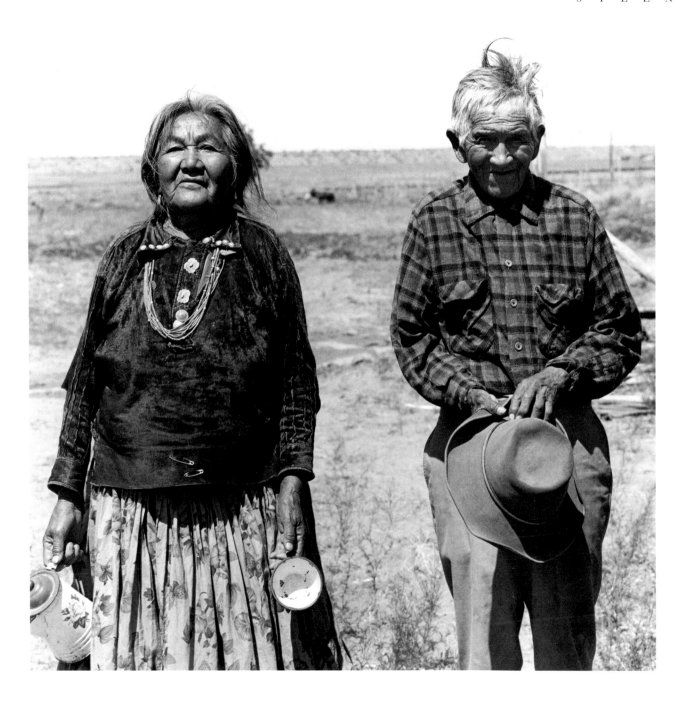

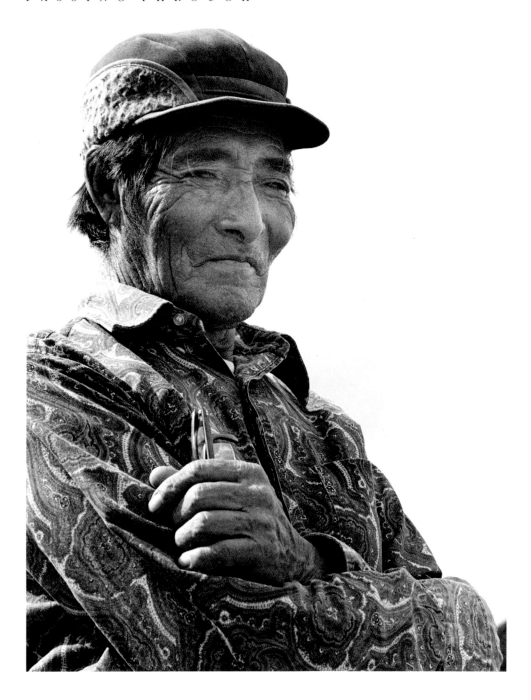

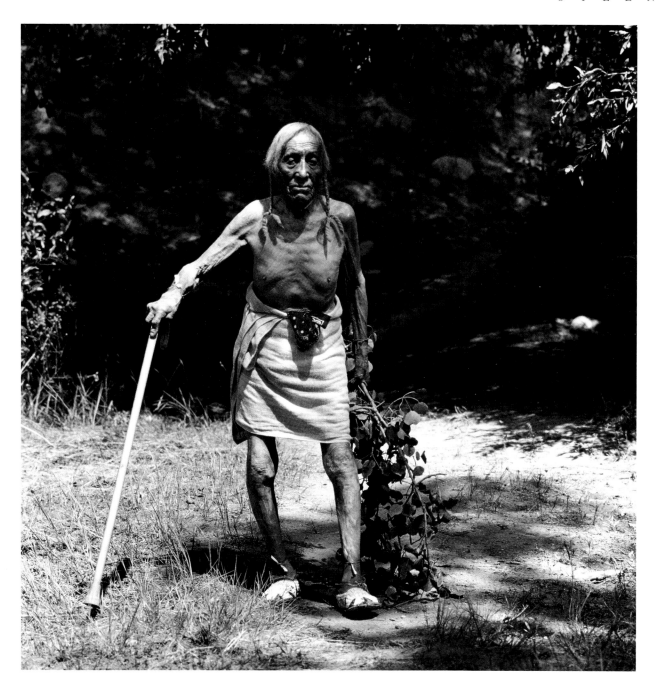

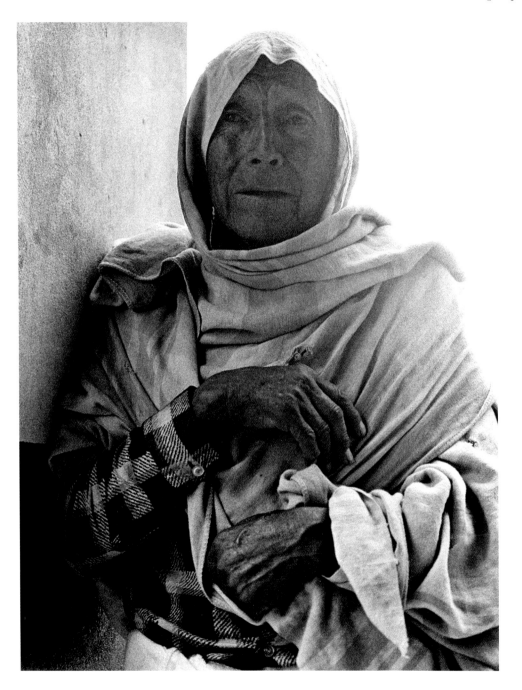

Nine | M Y S T E R I E S

The camera has with incredible regularity transported me into worlds that exist primarily on the edge of what most people consider reality. It has taken me into the twilight zone, put me in touch with time and brought me close to the stuff of history. In one of those moves I discovered the Matachines.

The Matachines dance has been part of New Mexican tradition for centuries. Its history can be traced back through Mexico and the Conquistadores to Spain, and from there into North Africa. In the eighth century, when the Moors introduced the dance to the Spaniards, it was a social ritual, an entertainment. But the dance done today in northern New Mexico is eclectic, like the growth of the high desert history itself, and is seen as a reflection of the triumph of the Holy Spirit in the New World.

Visually, the dance is a play of contrasts. White is cast against black, female against male, man against animal. The brilliant colors of the Matachines' costumes are contrasted with the ominous form of the dance and the haunting strains of the music. Shuttling and reshuttling like the machinery of a cosmic loom, the dancers move to weave together the major themes of good and evil and create the drama that ties the Matachines to their culture.

Here, I regard my cameras and film as a sketch pad; to me, the Matachines photographs are drawings of a spectacle as powerful as anything I have ever witnessed. In the darkroom, where I am able to pause long enough to isolate and examine each intricate detail, the mysteries of the Matachines unfold—not in a way that addresses any intellectual curiosity I might still have but in a way that satisfies the deeper artistic quest I am constantly making into myself and the life around me.

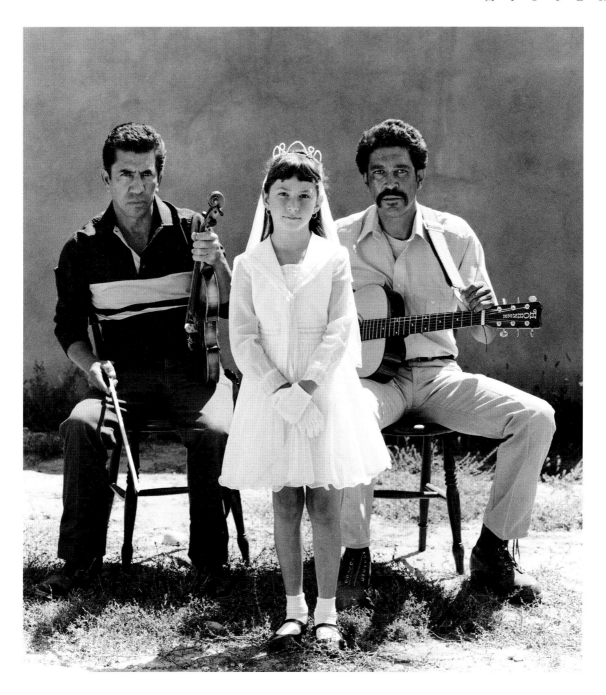

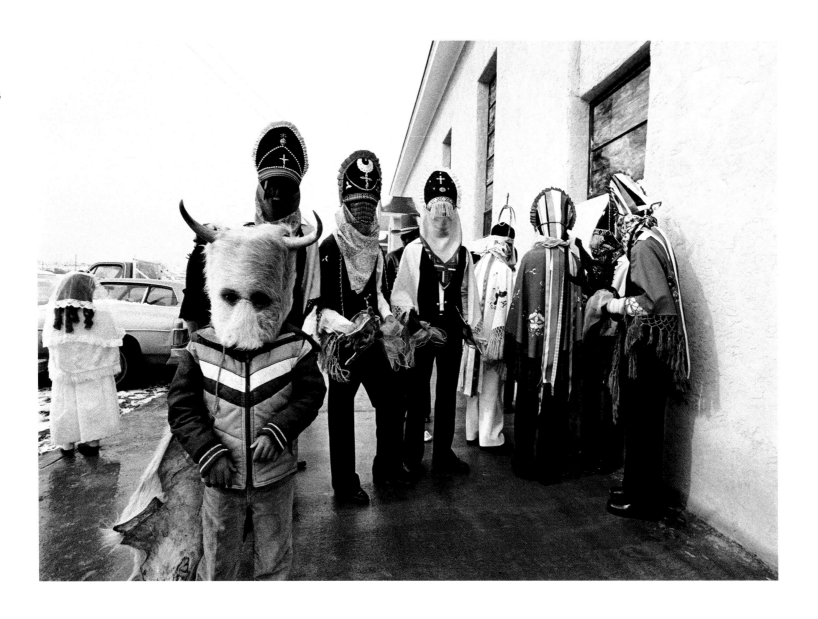

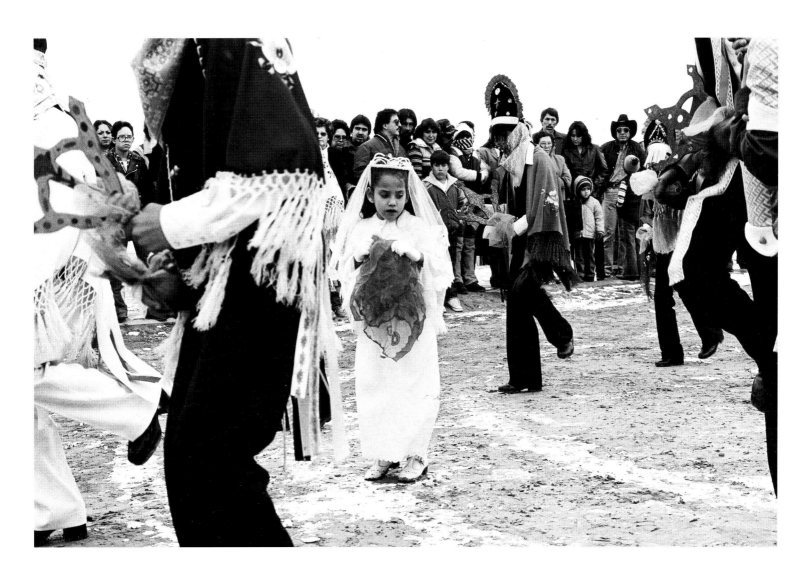

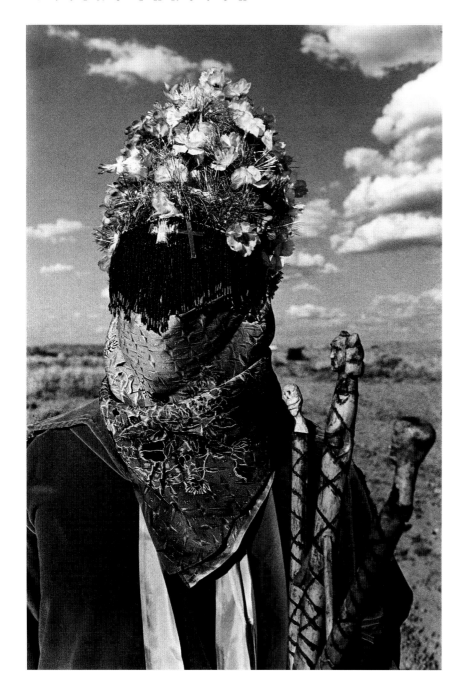

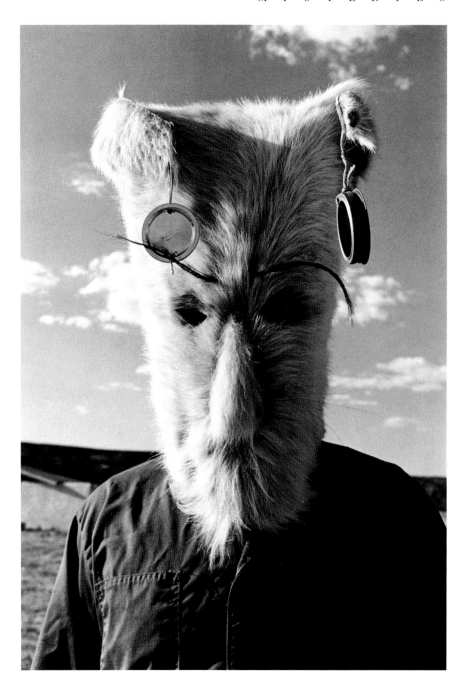

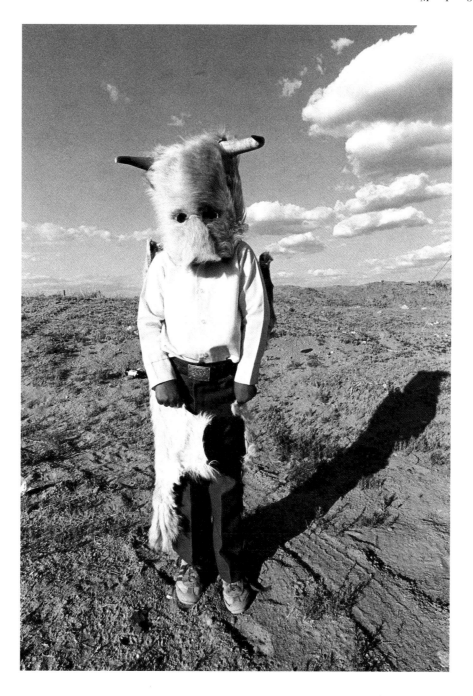

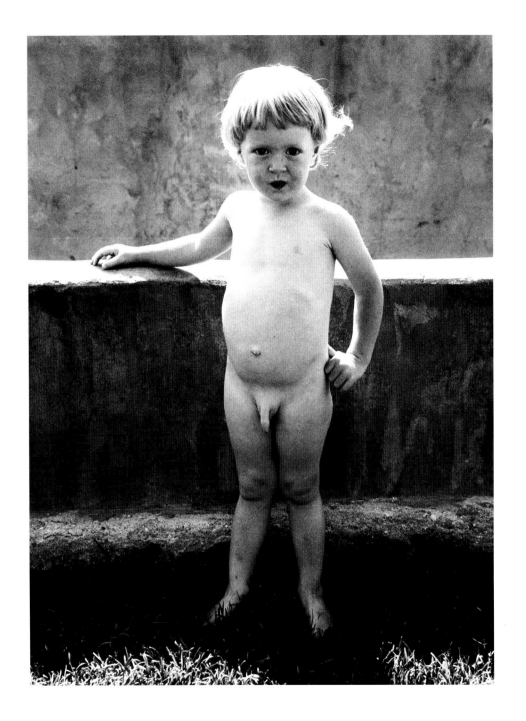

THE PHOTOGRAPHS

ii *Afternoon Hat*, New Mexico, 1984

vi *Mesquite*, Texas, 1973

2 *Designer's Dog*, 1975

4 *Green Aspen Meditation*, #3, Utah, 1987

9 *Passing I*, #7, 1969

10 *Passing I*, #11, 1969

11 *Passing I*, #20, 1969

12 *Passing I*, #3, 1969

13 *Passing I*, #1, 1969

15 *Passing I*, #16, 1969

19 *Muscle Beach*, Venice, California, 1976

20 *Lisa In Graphite*, #5, Irvine, California, 1979

21 *Lisa In Graphite*, #18, Irvine, California, 1979

22 *Lisa With Pink Wall*, Irvine, California, 1979

23 *Malibu I*, Malibu, California, 1982

27 *Lawrence Ferlinghetti*, San Francisco, California, 1967

28 *Robert Altman*, Santa Fe, New Mexico, 1985

29 *Anais Nin*, Portland, Oregon, 1970

30 *Dorothy Brett*, Taos, New Mexico, 1977

31 *Henry Miller*, Los Angeles, California, 1979

32 *Frank Waters*, New Mexico, 1988

33 *Robert Creeley*, Albuquerque, New Mexico, 1984

34 *Larry Bell*, Taos, New Mexico, 1984

35 *Eric Orr*, Venice, California, 1983

36 *Jim Morrison*, Portland, Oregon, 1967

37 *Jimi Hendrix*, Seattle, Washington, 1967

41 *Prison of New Mexico*, Santa Fe, 1985

42 *Head of Christ, PNM*, Santa Fe, 1985

43 *White Boy, PNM*, Santa Fe, New Mexico, 1985

44 *Orange County*, San Quentin, California, 1980

45 *Bodybuilder's Back*, Federal Prison, Lompoc, California, 1980

46 *Female Convict*, Grants, New Mexico, 1987

47 *Two Convicts*, Grants, New Mexico, 1987

48 *Blowout!*, PNM, Santa Fe, 1985

49 *Blitz & Speedy*, PNM, Santa Fe, 1985

53 *Louis and Floyd Sanders*, Bell Ranch, New Mexico, 1983

54 *Brian Thomas*, New Mexico, 1984

55 *Jason Eicke*, Casa Colorado, New Mexico, 1983

56 *Jake's Spurs*, Clarendon, Texas, 1984

57 *Bareback Rider*, Douglas, Wyoming, 1974

59 *Bullriding*, Pendleton, Oregon, 1972

60 *Calf Roping*, Pendleton, Oregon, 1972

61 *The White Bronc*, Montana, 1974

62 *Gary Green*, Bell Ranch, New Mexico, 1983

63 *Ladder Ranch Hands*, Hillsboro, New Mexico, 1984

64 *Hands, T O Ranch*, Raton, New Mexico, 1984

65 *Jim Eicke*, Casa Colorado, New Mexico, 1983

66 *Arlyn Norman*, New Mexico, 1983

67 *Emmitt Faulkner*, Hillsboro, New Mexico, 1984

71 *Mothers of the Disappeared*, Juarez, Mexico, 1987

72 *Artist's Child*, Juarez, Mexico, 1986

73 *The Winter Communion*, Guadalupe Bravos, Mexico, 1986

74 *Mother and Children in Jail*, Piedra Negras, Mexico, 1987

75 *Swimmers*, The Road to El Porvenir, Mexico, 1986

76 *Corona*, Nogales, Mexico, 1987

77 *Young Boxer and Dog*, Nogales, Mexico, 1987

78 *The Barber of Palomas*, Palomas, Mexico, 1986

114

79 *Man and Cat*, State of Chihuahua, Mexico, 1986

83 *Fear God*, Venice, California, 1983

84 *Sandia*, interstate 25, New Mexico, 1978

85 *The Guard*, Santa Fe, New Mexico, 1970

86 *The Secrets of Life*, Alcalde, New Mexico, 1982

87 *Waiting*, Portland, Oregon, 1970

88 *Christmas Eve*, Taos Pueblo, New Mexico, 1978

89 *La Favorita*, Talpa, New Mexico, 1977-78

93 *Taos Pueblo*, New Mexico, 1969

94 *Child and Dog*, Taos Pueblo, New Mexico, 1969

95 *Going for Water*, Taos Pueblo, New Mexico, 1970

96 *Generations*, Northeastern Arizona, 1969

97 *Lukachukai*, Lukachukai, Arizona, 1970

98 *Medicine Man*, Northeastern Arizona, 1969

99 *Jesus Mermejo*, Picuris, New Mexico, 1969

101 *Taos Man*, Taos, New Mexico, 1969

105 *La Malinche and Musicians*, Alcalde, New Mexico, 1984

106 *Matachines at St. Anns*, Alcalde, New Mexico, 1981

107 *Malinche and Dancers*, Alcalde, New Mexico, 1982

108 *The Death-Head Palma*, La Villita, New Mexico, 1982

109 *El Abuelo*, La Villita, New Mexico, 1982

111 *El Torito*, Alcalde, New Mexico, 1982

112 *Devon Hall*, Alcalde, New Mexico, 1982